MW00804853

Theater Appreciation

An Introductory Guide

Marshall Jones, III
Rutgers University

KENDALL/HUNT PUBLISHING COMPANY
4050 Westmark Drive Dubuque, Iowa 52002

Contents

🎭 Introduction 🎭

The telephone call came on a blustery winter morning. I was in my office overlooking a beautiful ravine. The caller identified himself as a representative from a publisher. I quickly stopped him—"Oh, no, I'm not interested in purchasing or assigning any books for my class. I don't like any of them out there. They're not what I need."

The caller was polite and stated he did not want to sell me a book, but wanted to set up an appointment to discuss me writing a book. Me? Maio. Flattering, indeed, but I ain't a writer. I produce plays. And I teach students at my alma mater how to produce plays. I don't write. Really, I don't. Me? Write a book ... OK, OK, Tuesday at 11 A.M.

Steve O'Brien, Acquisitions Editor for Kendall/Hunt Publishing, and I did meet on Tuesday at 11. I explained to him that most of the books on the market are designed for theater majors and are highly technical and detailed. Most of the students in my Theater Appreciation class aren't majors but are genuinely interested in theater. They need the basic, just the basics ... like a "Theater for Dummies." Eh, wrong publisher, but you get the idea.

I never envisioned myself as an author. And early on in this process, I experienced writer's block (scary, really scary). Once I began to visualize (or is it audio-lize?) lectures in my head, I just began to type away what I was hearing in my brain (like I'm doing right now). As they say ... the rest is history.

Teaching Theater Appreciation at Rutgers University each semester to 400 students is an absolute joy for me. I hope that at the conclusion of each class, I have been successful in recruiting a fair percentage to join the ranks of theater audiences. It is my sincere hope that all of the students, as well as the readers of this book, will develop a true appreciation of the art and craft of theater.

Please note that the perspective of this book may be a bit biased towards Broadway and the New York Theater experience. I have approximately 15 years of working in live entertainment in New York, so I can only speak what I know.

Marshall Jones, III
May 9, 2005

🎭 Acknowledgements 🎭

The thoughts, ideas, and concepts in this book are the culmination of years of theatrical study with some of the country's brightest minds coupled with my years of employment at some of New York's most prestigious cultural institutions. A great deal of appreciation and gratitude is extended to my professors who introduced many of these concepts to me in the early 1980s as an undergraduate at Rutgers University—Joe Hart, Avery Brooks, M.E. Comtois, Carol Thompson, Eileen Blumenthal, Vicky Hart, Eric Krebs, Hal Scott, Joe Miklojeik and Michael Nash among others; my guiding light through graduate school at New York University, Brann Wry.

I would also like to express appreciation to the executives who helped shape and guide my career—from my very first boss at the Hertz Corporation, Chuck Bertilini, as well as Lynda Zimmerman (Creative Arts Team), Leon B. Denmark (Newark Symphony Hall), Percy Sutton, the Honorable Charles B. Rangel (Apollo Theater), Tim Hawkins (Madison Square Garden), Howard Kolins (Radio City Entertainment), Alan Levy and Todd Lacy (Disney Theatricals), and Israel Hicks (Rutgers University).

Finally, thank you to my colleagues and friends who have supported me over the years. Especially my immediate family Sienna, Danielle, David, Cindy. Special thanks to Marshall Jones, Jr.—your spirit is alive within me. Two of the world's special women—Chantal and Mom!

About the Author
Marshall Jones, III

Mr. Jones has almost twenty years of theater and live entertainment management experience in a wide variety of key executive positions at some of New York City's most prestigious venues including the world famous Apollo Theater (General Manager), the world's most famous arena—Madison Square Garden (Company Manager), the historic landmark Radio City Music Hall (Producer), and most recently, Disney On Broadway's *The Lion King*.

Marshall was appointed as the President of the Non Traditional Casting Project, a not-for-profit organization that advocates for diversity and inclusion in the arts. Marshall, who is a member of the Dramatist Guild, has written six scripts and is developing two new musicals. He is also a member of ATPAM. Marshall earned a BA in Theater Arts from Rutgers University and an MA in Arts Management from New York University. He is also a member of the New Brunswick Arts Council, and, since 1990 Marshall has taught arts management as an adjunct faculty at Drew University in Madison, NJ.

Marshall is thrilled to be in the position to utilize his 20 plus years of theatrical training and expertise to launch an exciting new concept of theatrical presentation with the creation of an innovative, new, professional theater company—***Emerge.***

Name _____

Date _____

Class Survey

Place an **X** next to the appropriate answer(s):

"I am taking this class because ...

_____	An interest in theater
_____	To fulfill arts elective requirement
_____	To see plays
_____	Learn more about theater
_____	To get an easy "A"
_____	It was recommended
_____	To have fun
_____	Fits into my schedule
_____	To take class with friend(s)
_____	_____
_____	_____

Part I

The Basics

What Is Theater?

"A man walks across (an) empty space whilst someone else is watching him, and this is all that is needed for an act of theater."

Peter Brook
"The Empty Space"—1968

I love that definition.

What! What the heck kind of definition is that? Empty space…? Walking across a room. And who is this Peter Brook guy anyway?

What about Broadway and bright lights? Dancing girls. Fanciful costumes? What about acting? And singing and dancing! Chorus girls, for goodness sakes!

Let's try this again…

Theater: /thē-et-er/ dramatic or theatrical quality or effect especially measured by the response of the audience.

Webster's New Collegiate Dictionary

So this is a little better…right? More of the kind of definition we're accustomed to. Defining a sophisticated and enduring artistic experience that is probably as old as mankind is not so easy.

Or is it?

On occasion, complicated ideas can be best analyzed through simplicity—broken down to its lowest common denominator. Observe how a white-haired physicist named Albert reduced time, matter, and energy to one simple equation. Well, maybe you can't—I know I can't—comprehensively analyze Albert Einstein's Theory of Relativity but it's important to recognize the significance of the concept's simplicity.

So I like to consider Mr. Brook's definition of "an act of theater" as the theory of relativity of the stage—the essential components necessary for an act of theater.

Peter Brook, a highly creative and innovative British theater director, has had a profound effect on the development of theater in the latter half of the 20th century. Mr. Brook is internationally renowned for staging innovative productions of the works of famous playwrights.

In examining Mr. Brook's theory about "an act of theater;" there are two major factors to consider:

1. The first is the concept of ACTION. The man in the room is walking, in other words—he is *doing* something.

Walking might not be the most interesting action in the world but it's important to recognize that walking is an *active* happening. **Action** is an integral part of a successful theatrical experience.

Mr. Brook also asserts that there's someone else in the room. His second point:

2. Implies of the EXISTENCE OF AN AUDIENCE, another critical component for theater.

Theater cannot happen in a vacuum and no theatrical experience is complete without an audience. If no audience is present, then actors on stage are merely rehearsing. Only the presence of breathing bodies who are viewing the action completes the cycle.

The concept of live audience also separates theater from its sister storytelling mediums—cinema and television. You may have never realized it but as an audience member at a live production, you possess unique powers.

How?

Well, first of all, you have the ability to join the actors on stage. Just jump up there and join 'em—have a good time. Now, this behavior is not advisable, unless, of course there's audience participation and you've been invited to join the performers. Otherwise you could be arrested for trespassing.

However far-fetched jumping on stage uninvited may seem, as you sit in the audience the option to reach out and touch the actors does indeed exist. And the reality of that occurrence has a direct impact on your theatrical experience.

You observe them, and they observe you. As an audience member you are actively engaged in the action of the play—making judgments, laughing, crying. There's a constant give-and-take that exists with this relationship, and it cannot be duplicated in television and movies. Furthermore this experience can't even be duplicated in the theater because each performance on each night is a different experience from the previous night. Different performance, different night, different audience. A performance is like a snowflake...no two are the same.

Hand Crafted

As consumers of goods and services in this country, we are all familiar with the concept of mass production. Henry Ford galvanized this concept in 1914 by producing cars on assembly lines as opposed to usual individualized orders tailored to specific requests of the buyers.

Products that are mass produced are designed to cost consumers less money and are based on the premise of selling goods to as many people as possible. The vast majority of the purchases most of you make on a regular basis have all been produced and marketed in this manner. Fast food, clothes, movies, cars as well as thousands of other items are manufactured and marketed this way.

Imagine, if you will, having an automobile specifically made for your taste. Or, instead of purchasing a McBurger that's been sitting under a heated lamp for 20 minutes, imagine a chef coming to your house and cooking you a perfect meal exactly to your personal taste. Picture a fashion designer measuring and examining your physique, then creating the perfect outfit for you. Instead of having a Kodak photo taken, imagine a first-rate artist painting your image in wondrous, colorful oils.

Each one of these instances poses a hand crafted item tailored to your specific wants and requests. Now, of course, you realize the actual cost of these items obviously will be considerably more than purchasing a burger on the dollar menu.

But work with me here; imagine that you placed this order....

Well, with this in mind, welcome to the world of theater!

By understanding the mass production concept, you will come to realize how/why professional theater in this country is so expensive—it is an art form that is specifically crafted for you— the audience. Each show is different and unique. Same dialogue, same stage, same costumes, but the major difference is YOU! The audience.

As a member of the audience, all of the labor and expertise in putting the show together was created with you in mind, like a tailor-made suit.

As with most hand crafted enterprises, there exists a huge dependency upon human labor. The personal chef can't send a machine to do his work (or maybe he can—rent Charlie Chaplin's brilliant movie *Modern Times* to find out). And we certainly can't have machines replace the actors on stage. Maybe the future will hold this with holographic images and cloning, but until those days are here, it's all about the experience created by having that performer live on stage right in front of you. It's that simple.

Theater vs. Film and Television

I love the cinema. Going to the movies has always been a thrilling event; however, the title of this book is *Theater Appreciation*. Frankly, I'm not qualified to write a book called *Movie Appreciation*, but in order to illustrate the power of theater, it's important to analyze the distinctions between film and television. This helps to frame the particular nuances of each medium on a side-to-side basis.

Taking into account our hand crafted analysis, movies, then, definitely exemplifies the use of mass production. Its production process is similar to an assembly line where thousands of prints of a film are distributed to movie screens throughout the country, and indeed the world. (The power and influence of Hollywood abroad is amazing as movies are one of the USA's top exported products.)

Once more, let's consider Mr. Brook's thesis—whereby a person enters a room and another observes. Frequently, particularly in the early morning or late evening, movies are flickering away at the multiplexes in the shopping mall and no one is present in the audience.

Can you imagine actors performing on stage without an audience? When this happens, we call it a rehearsal.

Chicken or egg theory—what would happen if tickets to a play were sold but no audience showed up? Would the actors still perform in front of an audience filled with empty seats? What if there was a snowstorm, you sold a bunch of tickets but only two people made it? Would the show still go on?

I hope so. Those two individuals braved the storm and are entitled to a show. What would the actors think? Would they rather have the night off—get back home to shoveling snow?

Visual images are very important with film as the story is communicated through the use of pictures. The movie screen is sixty feet in diameter and uses the latest technology of color and brightness while audio sound in Dolby and 5.1 seems so real and naturalistic (Ever see/hear those opening sequences about movie etiquette and a cell phone rings and baby cries?).

The power of being able to create a moving image of that size and stature gives movie makers the ability to tell a story by using the composition of pictures! For movies, that's how the story is told—through pictures. Think of your favorite movies and I'm sure there are some unforgettable images in your mind that help tell the story.

Memorable Picture Images from Movies

- Sylvester Stallone as *Rocky* running around the top of the museum in Philadelphia waving his arms.

- Robert DeNiro as Jake LaMotta in *Raging Bull* when he is destroying his knuckles by punching a prison wall.

- Final shot in the opening scene of blood-soaked snow in *Gangs of New York*

Heck, movies were first called "Motion Pictures," and eventually the two words became truncated to just "movies."

So film merely uses a series of pictures to tell the story. Don't believe me? Rent a well-crafted movie and turn the sound down; you'll notice that by watching just the pictures alone, you can follow the story.

Even though there are similarities, the experience of television greatly differs from the cinema. (I must confess that with the exception of sporting events and a few shows on the non-commercial networks, I don't watch much television.) Compared to movies, the screen of a television set is miniscule. Also, while watching television, you are usually in a familiar and comfortable environment—either your home or someone else's home.

OK sometimes one might go to a sports bar to watch a game, but primarily, television viewing has a very personal connection to it. You are not experiencing the show in a strange and public place but in rather comfortable, personal confines. This has a direct impact on your experience and more importantly, is the most effective manner to tell stories.

Producers of TV shows utilize the faces of the actors to communicate the story. And a close-up of a performer's face on a 20" set is about the actual size of a face! A twitch of an eyebrow and pucker of the lips can be easily captured and viewed by the TV audience. Crime dramas, daytime dramas, and even sporting events utilize the close-up techniques of highlighting the face to help tell the story. Don't use the old "turn down the sound" technique for TV though because it's a medium that also depends heavily on dialogue.

So movies use pictures and TV uses faces…what does theater use to communicate its stories?

It's plain and simple—the environment! Whether the creative folks producing theater are consciously planning or not, the overall environment is a major part of the whole experience of theater. The design of the theater itself—the seats, the sightlines, the ushers, the actors on stage, and the members of the audience, all provide the necessary elements for experiencing the story.

Let's repeat that again, theater communicates through the theater itself (the empty space), the actors on stage (the man walking across the room), and members of the audience (the man watching the man cross the room). As Mr. Brook so eloquently stated in his landmark book, those components are the vital ingredients for a theatrical experience.

House to Half

This is usually a stage manager's first queue to the show's running crew. When she utters those words, the house lights in the theater slowly begin to dim. A familiar, eerie hush inevitably comes over the crowd of strangers as the room begins to travel towards darkness.

House to Half

This is a cue that the Stage Manager will relay to the light board operator, who then dims the lights over the audience (also known as House Lights). This cue is usually communicated over headsets. And it's usually one of the first cues of the show.

For me, this moment of gleeful anticipation is personally one of the most exciting parts about attending a show. Predictably, whether the theater is on a street called Broadway or on a road called Main Street in small town in Indiana, the outcome of "house to half" is the same—a splendid moment of silence that's filled with eagerness and expectation. The dark air in the theater is filled with the audience's eagerness and enthusiasm for what's-to-come.

Much can be communicated in the collective silence—it's a preparation for an impending enlightening theater experience—a communal hush of imminent emotional passion. The genesis for this anticipation is so individual, so personal. Each audience member has his/her own personal emotional causation—first date, anniversary, fan of performer/playwright/composer, relevant subject matter—the list continues but all of those various sentiments for purchasing a ticket help to create and contribute to the power of the opening moments of silence.

I love this moment. After more than 25 years of attending the theater and working in the business in all kinds of capacities—I really enjoy the silent moment of anticipation that opens a show.

Moments like this make theater the special art form that it is. This kind of group anticipation doesn't exist in our sister-storytelling mediums. With film, the anticipation is a result of the ongoing sneak preview trailers and commercials. Television, well, most of the time, no true audience exists to share a collective hush as television is often watched alone.

In music concerts, when the house lights dim, the audience usually goes bonkers anticipating their favorite star. In live athletic events, perhaps a similar anticipation occurs somewhere between the end of the National Anthem and the tip-off/kick-off/opening pitch. But it's certainly not silent. Much can be said in silence.

The lone exception to this experience in the theater is an audience comprised mostly of young students—whether in high school, middle, or elementary. Without fail, they all respond the very same way when the house lights go to black; they scream their heads off! I don't understand this but it always amazes me. There's something appealing about that response by students.

As a collective, young students aren't afraid to address their opinion when a show is dull and boring; they won't be still and silent, but rather demonstrative and outward. The positive perspective of this is that with student audiences, you know whether they're enjoying the experience—whether they are "with" you or not. They'll let you know. Very quickly.

🎭 Acts of Theater 🎭

Pay close attention to events that can be described as "acts of theater," such as attending church service, sitting in a classroom, or watching a child in a playpen.

List the ACT: _____

List the ACTOR: _____

List the OBSERVER: _____

List the ACTION: _____

Describe why this is an ACT of Theater: _____

List the ACT: _____

List the ACTOR: _____

List the OBSERVER: _____

List the ACTION: _____

Describe why this is an ACT of Theater: _____

List the ACT: _____

List the ACTOR: _____

List the OBSERVER: _____

List the ACTION: _____

Describe why this is an ACT of Theater: _____

List the ACT: _____

List the ACTOR: _____

List the OBSERVER: _____

List the ACTION: _____

Describe why this is an ACT of Theater: _____

 # The Power of Storytelling

In addition to sex and death, one other constant of human existence that seems to transcend all cultures on our planet is the enjoyment of a good story. Human beings are compelled to attach themselves to the psychological magnet of the well-crafted story. This connection can be made by hearing a good story or reading a good story or seeing a good story—either on screen (large or small) or on stage.

There is also a desire for the public to become involved in stories—why is there so much interest about Brad and Jennifer getting divorced?

As I've watched audiences file into theaters over the years, I've asked what compels them to attend. Fundamentally, I believe a latent curiosity exists about how others live their lives. There's a compelling desire to discover if others share the same hopes/desires/fears. Accordingly, by examining others, our capacity to learn/grow/develop from them increases.

I've no scientific proof, but anecdotally speaking, I believe theater audiences, generally, want more than to be entertained. Their psychological desire for shared interaction is higher. They want to be directly challenged and exposed to the depths and breadth of the human condition. And it's through this examining of others that we can turn the morals of the story, the lessons of the story, inward. To reflect and examine how we become individually affected. A wise proverb from the Orient declared:

> He who knows others is wise.
> He who knows himself is enlightened.
>
> Wise Chinese Proverb

Why are human beings compelled by stories? There's something deeply psychological about the strong desire to communicate our stories to each other.

Storytelling

The vast majority of plays written, generally convey a story with a beginning, middle, and end where there are characters that the audience can relate to. This is not always the case as some great works of theater examine concepts and ideas. These works challenge audiences to think "outside the box." For the purposes of this book, we will closely examine plays of simple structure that were written to tell a basic story.

In everyday life when we hear/tell a story, this is done to create involvement. Oftentimes it can be labeled as gossiping. But it's important to understand what drives our need to share and more importantly, our need to know.

Remember your childhood, in Little League, perhaps—you hit the winning homerun in the bottom of the ninth but your parents weren't able to attend the game. As you're rounding the bases, you're probably thinking of how you can't wait to tell them, or anybody else in your life who means a lot to you but who's not present at the game.

By telling this story, your personal experience becomes more complete and richer because the teller and the listener become connected. This is definitely true for significant and pivotal events in our lives. Take a moment to think about your past experiences when you explained happenings and events in your life that were important. How did it feel to finally explain and share the experiences?

As a listener, the power of storytelling can also be seen in helping to experience the event. As a listener/receiver you are vicariously experiencing the story through your own point-of-view. This helps you experience the story in a truly personal and individual fashion.

I vividly recall the most vicarious experience I ever had watching the movie *Back To The Future*. Simply because of the age similarities with the main characters, I was clearly able to relate to the Michael J. Fox character, Marty McFly. My own mother graduated from high school in the 50's, so I vicariously experienced the movie from my own personal point-of-view. Trying to comprehend how I would cope with traveling back in time and having my mother wanting to date me. Yikes!

The Incredibles

I had the pleasure of taking a group of kids to see Pixar's marvelous computer animated movie. They included: my teenaged nephew, my 8-year old daughter, her 5-year old girl friend, and the 5-year old's younger brother. Afterward, I asked them to tell me their favorite characters:

- Teenaged nephew: Dashiell (teenaged boy speedster)

- My daughter: Violet (teenaged Invisible Girl)

- 5-year old girl: Violet (basically copying my daughter)

- 3-year old boy: Jack-Jack (the human torch baby)

- Me: eh, who else—the father, Mr. Incredible himself.

This little account clearly demonstrates the power and relevancy of point-of-view of a story.

Vicarious enjoyment of stories can also be therapeutic. It allows you to externally come to terms with a particular experience as well as stretching your imagination.

Finally, the receiver of the story can grow. He/she can learn and discover more about the complexities of mankind and to paraphrase our Chinese proverb—increase knowledge of himself to become more enlightened.

Storytelling

Are you a good storyteller?

Or do you know someone who is?

Good storytellers can say the same basic words as the not-so-good-storyteller, but yet somehow the good storyteller's story is more interesting and engaging.

Well, there's also technique involved. In the meantime, think about one of your favorite stories to tell. Think about the people (characters) involved. And the conflicts involved. And how those conflicts got resolved.

The Power of Taste (or Point-of-View)

I don't like spicy foods. Never have, never will. I just can't handle it and don't enjoy it. That's my personal taste and there's nothing that anyone can do or say to change that. And last I checked, it's not a crime to dislike spicy food.

When going to the theater I believe it's important to recognize the power of an individual's personal taste. So after a show when you find yourself enthralled beyond measure and the person you came with was bored stiff, don't try to 'figure' out what's wrong (with either you or him). It's a matter of personal choice, and what is important to figure out is simply to respect the other person's point-of-view.

Like my spicy food analogy, the bored guy won't change his mind. Don't try. What you could do is to try to understand *his* point-of-view. One can develop a deeper understanding of another's viewpoint without agreeing with it.

I encourage everyone to develop this skill because it will serve you well in the long run. Whether trying to better understand your boss or your husband/wife—it's a good skill to have. Put it to use when you go to theater and have discussions afterward.

🎭 Storytelling 🎭

List favorite movies (or plays), then write the character that you were vicariously attached to. Then detail why?

Movie/Play Role Why?

_____ _____ _____

Movie/Play Role Why?

_____ _____ _____

Movie/Play Role Why?

_____ _____ _____

Movie/Play Role Why?

_____ _____ _____

Briefly describe a memorable story from your life.

Answer the questions below.

List the main character: _____

What does the main character want? (objective) _____

List other characters in the story and what are their objectives?

Character Objectives

_____ _____

Character Objectives

_____ _____

Character

Objectives

Character

Objectives

Character

Objectives

The Audience

Does this situation sound familiar? You are at home in your den all alone watching TV. A hilarious scene/event comes on. You are laughing hysterically as you call your sister/brother/father/mother or whoever is within ear-shot to come quick and see this!!!

Why'd you call this person to join you?

Because the act of involving others somehow completes the situation. As we discussed in the last chapter, humankind has a strong psychological and sociological desire to share experiences. Whether the news to share is exciting, or not-so-exciting, both have impact. Think about the time you got a new job! Or when that cute guy/gal finally asked you out on a date! Or when that cute guy/gal broke your heart. Who did you want to connect with?

Audiences of today, particularly younger ones, are the most sophisticated in the history of mankind. This is simply because today's audiences have been exposed to an unprecedented amount of stories through all kinds of media.

Howdy Doody Time and Sesame Street

I remember quite vividly when *Sesame Street* first premiered. I was in 1st Grade and this show was specifically tailored for my age group. I believe it came on three days per week, and of course eventually it was aired quite regularly on a daily basis. However, only a generation before *Sesame Street*, there was the *Howdy Doody Show*, a weekly aimed at young kids in general. And not every household had television sets when it was Howdy Doody time, (statistics show that in 1955, only 15% of households had TV sets).

> Now of course, there's a show for the 3-year olds—*Barney*, and even a show for 2-year-olds—*Teletubbies*. Of course, a show for 1-year-olds is probably in development.
>
> In the 21st Century, there are entire networks operating 24 hours a day with programming specifically for kids. There's access to videos, DVD's, movies, computer games, the Internet—all with the capacity to expose young minds to the never-ending world of storytelling.

Being an audience member of live performances enhances the world of storytelling because the story becomes more complete through sharing it with a group of strangers. Both parties—performers and audiences—have agreed to a set of etiquette standards that have been established over time and are socially acceptable.

Let's examine this audience behavior concept a bit further by observing an audience at a tennis match. Silence is the established code of behavior during tennis play (although on occasion at some raucous Davis Cup matches of international competition, this rule is out the window). The chair umpire insists on quiet to the point that misbehaving spectators could be escorted out when they don't comply.

Now put the tennis set of standards at, say, a basketball game while a player is at the free throw line about to shoot a foul shot that will decide the outcome of the game. For the Home team—silence exists, as the crowd wants the player to concentrate better. For the Away team—pandemonium exists as all kinds of chants and obscenities are frantically yelled to spoil the player's concentration. Would an official be able to demand quiet at a basketball game?

It is really important for the young theater goer to understand that Theater also has established codes of behavior. Frequently youthful audiences seem eager to apply behavior more fitting to a movie theater (or worse a basketball game) to a live stage play.

This is not appropriate as the two mediums and how they relate to an audience are entirely different. The main difference is talking. Oftentimes movie audiences will talk to the screen. This has puzzled me because the actors can't hear you and won't talk back (this talking is apparently for the 'benefit' of the crowd at the movie). This is not true on stage. Actors on stage can usually hear you and sometimes they do talk back to unruly audience members.

> ### Laurence Fishburne
>
> This little happening occurred in NYC theater folklore where Mr. Fishburne, talented actor probably best known as Morpheus in popular *Matrix* trilogy, was performing *The Lion In Winter* on Broadway. During a performance one day, a ringing cell phone interrupted the show. And what was Mr. Fishburne's response?
>
> He yelled at the offending member of the audience: "Turn your f—ing phone off!"
>
> This story has officially entered the category of Urban Myths as I've heard it described that Mr. Fishburne grabbed the cell phone and began conversing with the person on the other end. Reminds you of the kindergarten game *Telephone*.

Distance

Say you're at the Met (eh, the Metropolitan Museum) and you're looking at a painting. Are you standing a few inches away? Or do you step back to take it all in? That's called "distance" —finding a comfort zone where you can effectively absorb the artwork. That exists for theater as well. Contrary to popular belief, sitting in the front row doesn't give you a good vantage point (at a concert, perhaps, but not a theater production). A front row seat is like viewing the painting from a few inches away. My personal preference is dead center in mid-orchestra section. Also, the first few rows of the mezzanine are always great seats.

Lateness

Professional theater craftspeople—actors, stage crew, wardrobe crew, stage managers, etc.— all know very well the importance of being on time. Under Union regulations in the Broadway world, an actor could be down right lousy in his role but it would be very difficult to terminate his contract for his bad performance. Ah, but if he's habitually late, management can easily fire the anti-talent for tardiness. Management can also penalize him and put on his understudy when he is late to the theater. And that means his salary is docked by one-eighth.

This is an unspoken code in professional theaters all across the country. Promptness is expected; tardiness is viewed as unprofessional. Don't be an unprofessional audience. Be on time. Or better yet, arrive early.

Being early will allow ample time to read through your Playbill. As you probably know, you will find biographies about the actors and other creatives such as the playwright, the director and designers. Sometimes the Playbill will have interesting articles about the play's subject matter.

Latecomers are very disturbing to fellow audience members and are definitely disturbing to the actors. Yes, most of the time, the actors *can* see you. I mean, c'mon, ever notice the older theaters on Broadway where the leg room is only sufficient if you're a child under five (and most Broadway theaters don't allow children under five). When the latecomer—who was

stuck in traffic and spent 20 minutes searching for free parking—finally arrives, the whole row is inconvenienced and has to stand up. So the actors on stage see a whole row stand up. And the fortunate folks in the row behind the standing-row get a nice view of a few dozen backs instead of the action on stage.

Photography

If you're viewing a baseball game on television and a superstar hitter is at bat, it's amazing to view the flashes of cameras going off almost simultaneously. It brings to mind a display of fire works. In a theater environment, even one camera flash is a distraction. It's also illegal in professional productions as the performance of the actor is protected by the union as well as copyright laws. Photography is prohibited in professional theaters.

Dress

Fashion to the theater has evolved over the years. Examine the garments worn at a Broadway show and you'll notice the gamut—from nicely tailored suits and dinner dresses to blue jeans and, yes, t-shirts. Theater traditionalists (and most theater folks are traditionalists) deplore the "dressing down" of Broadway. The feeling is that Broadway represents the finest theater in the world; therefore a certain amount of respect should be accorded. Personally, I love the individual freedom of choice (and who's to say dressing in jeans is disrespectful?) But I must confess it's always been heartening to glance in the lobby and observe people who definitely have defined their attending a Broadway show as an event—(hair neatly combed, dress finely fitted, nails polished, etc.). But most importantly, I hope that patrons of the professional theater dress in an appropriate manner that is also comfortable.

Eating/Drinking

Most theaters on Broadway, and throughout the country, have a "No Eating or Drinking" policy. At the movies, the cinema experience is somehow not the same if you're not munching on popcorn, which probably costs almost as much as the movie! However, food and beverages are generally considered a no-no in the theater. Munching on popcorn can be disturbing to the actors on stage and to your fellow audience members. Remember, Tom Cruise won't hear the crunch of the popcorn as he chases bad guys. But the sweating performer playing Hamlet 10 feet in front of you probably will.

Some theaters have begun to relax these policies. The recent Broadway run of *Cabaret* re-created an actual cabaret and drinks were served. The economics of the time probably have something to do with the easing of the food and drink policies on Broadway. Theaters make more money if they allow food/drinks inside. Also, as far as NYC theater is concerned, several recent developments in sophisticated pest control have allowed producers to offer food in the theater without as much fear of having un-ticketed four-legged guests watching the show too.

Electronic Devices

Want to infuriate a stage actor? Let your cell phone go a-ringing while he's performing. The thought of passing a law banning the use of cell phones in a theater was unheard of a mere 10 years ago. However, the state of New York just passed this ban. Cell phones are so prevalent now that virtually every time you go to the theater, at the start of the show, you will hear

an obligatory announcement reminding spectators to turn off the cell phones. Quite often, the announcements are pre-recorded by the stage manager.

Creative Cell Phone Announcement

I attended a production of Shakespeare's *Much Ado About Nothing* at the Globe Theater in London. At the top of the show, the Constable, who is a character in the show, slowly and authoritatively marched out to center stage and methodically declared:

> "Ladies and gentlemen, please turn off all mobile phones, because as you know, they did not exist during the Age of Elizabeth, her majesty the Queen."

When you go to productions, see what creativity is used for the cell phone announcements. Keep in mind that *Much Ado* is a comedy and the funny announcement worked because it also captured the spirit of the play. Not all plays will lend itself to humorous announcements but I always look forward to seeing if any creativity is used.

Unfortunately, these announcements are necessary because even the most well-intentioned theater goer might inadvertently forget to turn off his/her electronic device. And let me caution—turn if OFF, and don't just set it to vibrate. If your phone goes off while on vibrate, the actors probably won't hear the vibrating but the people sitting next to you will. And if the scene is a quiet one, so will the next few rows.

Finally, with the increased popularity of text messaging, some theater goers feel that sending text during a show is OK because it doesn't make any noise. Uh, well, the theater is dark therefore you will have an annoying glow around your seat that can be seen by your fellow audience members as well as the actors on stage. Ditch the text messaging! Hey, that's what intermissions were made for. And remember to turn the phone off again after the intermission.

Cell Phone Story

Everyone in the theater business has at least one ridiculous story involving cell phones. Mine occurred while sitting in the audience during a very personal and intense scene. The woman was sitting right behind me and her phone went off. She kept on yelling "no one ever calls me!! I never get any calls!!!" over and over again as she struggled to find her damn phone, and subsequently ruined the intense moment for both the actors on stage and the audience.

Demographics

The make up of the individuals comprising the audience also has an effect on your experience. When you go to the theater, take time to examine the demographic make-up of the audience. Are the ages similar to yours? Is there socio-economic background similar to yours? If so, how does that impact on your experience of the play? If not, how does **that** impact on your experience?

Audience of Accountants

I recall a while back, a Big Eight Accounting firm purchased all the seats for one performance of Madison Square Garden's musical production of *A Christmas Carol*. The company provided this offer as a gift to the employees and their family. During the course of the show, the audience of accountants was virtually silent. The actors were wondering if they were asleep. Generally speaking, personalities of accountants aren't the most demonstrative, but they enthusiastically applauded at the end.

Applause

This is such an important component of the theater experience. There was even a show where applause was the main subject matter (of course the title of that show was *Applause*. It ran in the early 70s and starred Lauren Bacall).

I always marvel at how the theater audience differs from audiences in the music world. The moment a conductor steps on stage, the audience burst into respectful applause. And, no, this phenomenon isn't just limited to classical music, go to any pop concert. Music fans aren't shy about expressing their devotion to their artists.

Applause on Entry

Some theater performers get the "conductor" treatment—thunderous applause when they first enter the stage. Four-time Tony Award winner, Audra McDonald; Tony winners Bernadette Peters will get one. So, too, Harvey Fierstein (*Hairspray* and *Fiddler On The Roof*). However, audiences went bonkers when Sean "Puff Daddy" Combs made his entrance in the recent Broadway production of *A Raisin In The Sun*, which subsequently brought a whole new demographic to the Broadway world.

> Because of their popularity, movie celebrities and TV personalities tend to get AOE's. This is more a result of hard-core fans of the celeb, rather than appreciation for their skills by veteran theatergoers. We're skeptics.
>
> Although I do recall catching a production of *RENT* with Scary Spice playing the role of Mimi. *Yes*, the same one that was once with the Spice Girls. She did not get an applause on entry.

Theater audiences, however, are a tad more skeptical. Theater folks are like Missourians—show me, first.

Applause usually occurs at the end of acts. Although when a scene sizzles, theater audiences will give up the love. In musicals, applause is given after a song (see, the music thing again!) When the applause is exceedingly long and adoration is bursting through the footlights, this is called a showstopper. Jennifer Holliday singing "And I am telling you" at the end of the first act in *Dreamgirls* is a famous showstopper.

Sometimes in a non-musical, straight play if the scene really sizzles and/or is extremely funny, audiences will applaud at its conclusion.

Applause is heard at the end of the show (you can usually tell that it's over); this is called a curtain call—an acknowledgement of the actor's and other craftsmen's work. The curtain call has matured in recent years particularly on Broadway. Today directors consider it an extension of the show and will add intricate choreography and components of the story. Again, this is a way that the show can justify the high prices. Tony Award winning director/choreographer Susan Stroman really raised the bar a few seasons ago when she staged a Broadway revival of *The Music Man*. During the curtain call, she had the entire company of actors playing the trombone. It was delightful.

Elaborate curtain calls are not appropriate for all plays. After just witnessing Bernardo killing Tony in *West Side Story*, do you really want to see Tony dance in the curtain call?

Supposedly if the work just seen was particularly superlative, the audience will stand and applaud. This is called a Standing Ovation. Most shows on Broadway will get standing ovations whether the show was superior or not. I've always found this puzzling. My little theory is that, relatively speaking, audiences spend considerable amount of money for the leisure entertainment experience of Broadway theater. Standing at the end kind of validates the expense, it seems.

If you further analyze ovation, there are two basic categories. One is an immediate response—as soon as the curtain call begins audience leap to their feet in appreciation. Then there's the obligatory ovation. Those usually begin with patches of people expressing their appreciation by standing. A patch of four. Another patch of five. Well, the people sitting behind those patches can't see, so they begin to stand. And slowly but surely, you have yourself a standing ovation.

If you were a performer, which type of ovation would you prefer—one that's spontaneous or obligatory?

How to Watch a Show

There's two basic ways—passively or actively. With the former, you are detached and disengaged with the action of the story. You are looking at your watch, wondering what time it will be over. You might be observing peculiar elements about the actors (hey, her eyebrows need plucking.) Engaging the audience passively is not the goal of most theater creative professionals.

Actively watching a show means you are engaged in the action. You are constantly asking questions about the character and their motivations. You inherently want to know what they are going to do next. These internal questions stimulate your mental involvement with the show. You become connected to the show whereby your interest in the characters is now emotionally based. You care about them.

Audiences are the observers of action. But you are not merely bird watching. In other words, there's a give and take. Each audience is unique unto itself.

The Investment

Attending the theater is not quite the same as attending a movie or even a sporting event. Going to a show is a planned event. I'm sure this occurred at some point in your life, slow summer evening, not much happening: "Hey, let's catch a movie." But did you ever remember saying; "Hey, let's catch a play!"?

For theater, you purchase the tickets in advance. You have to make arrangements—baby sitter, parking, transportation, etc. Most theater goers dine at a restaurant prior to the show. Naturally the audience wants a return on their investment—hey, they want a good show.

The Theater or Is It "Theatre"?

Generally speaking, "theater" is spelling in the US, and "theatre" is the spelling in the UK. They also spell program—programme. And organisation. But since we're in the good old USA, we'll stick to spelling theater as *theater*.

Theater Environment

There are four basic structural environments for theaters—proscenium, thrust, arena, and environmental.

Most common is the PROSCENIUM, which has a clear delineation between the action on stage and the audience. In this arrangement the audience faces the stage in one direction. (Most high schools have auditoriums that are classic proscenium style.) The stage is framed— this is called a proscenium arch. This arch is viewed as a "fourth wall" which is imaginary; it's as if the audience is peering in on the action of the play. When characters talk directly to the audience—this is called "breaking the fourth wall."

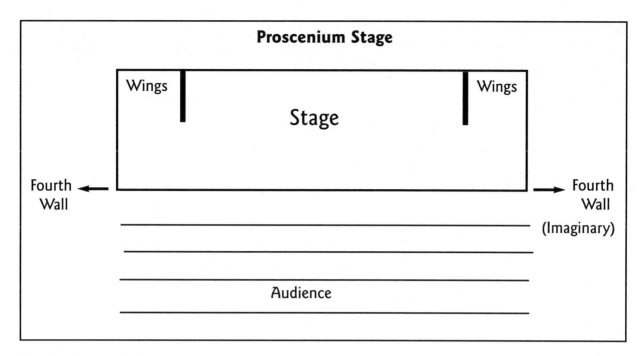

Figure 1. Proscenium
Note, the demarcation of the fourth wall between the stage area and the audience. Also note wing space which can serve as storage areas (or even running room for dance concerts) and crossover.

The proscenium style also allows for wing space, crossovers, and a fly loft. Wings are the sides of the stage and are usually out of view of the audience. Scenery and costumes are usually stored there as well as space for stagehands and operators. Crossover is just that—an upstage passageway that allows the actor to cross over to one side without being seen by the audience. A crossover can be a black curtain or painted backdrop, or a cyclorama (white backdrop that's colored by lighting). A fly loft is the area directly above the stage, which allows scenery to be lifted into the air and out of the audience's sight.

Depending on the play, all three of these structural elements (wings, crossovers, fly loft) can be vital in presenting a show such as multiple settings, trafficking complex entrances and exits, and quick costume changes.

Traditionally there was a curtain separating the stage from the audience. The curtain would rise at the start of the show (that is why some people refer to the start of a show as curtain time). Curtains are not as common as they used to be as directors like to have the audience observe the scenic design prior to the start of the show.

Fourth Wall. Establishing a fourth wall is one of the advantages of staging a show in a proscenium venue. The Fourth Wall is the imaginary plane that separates the stage from the audience. In realistic dramas, the action of the play occurs on stage as if the audience does not exist. In fact, it's like the audience is peaking into the lives of the characters on stage. When a performer talks directly to the audience, this is called "breaking the fourth wall."

The THRUST structure is just that—the stage thrusts into the audience. The audience surrounds three-quarters, or a semi-circle, of the stage. The thrust is one of the oldest

arrangements having been used by the Greeks and Elizabethans. The actors can feel a closeness with the audience as they virtually surround them. Thrust stages present design challenges as large scenery obstructs the audiences' view.

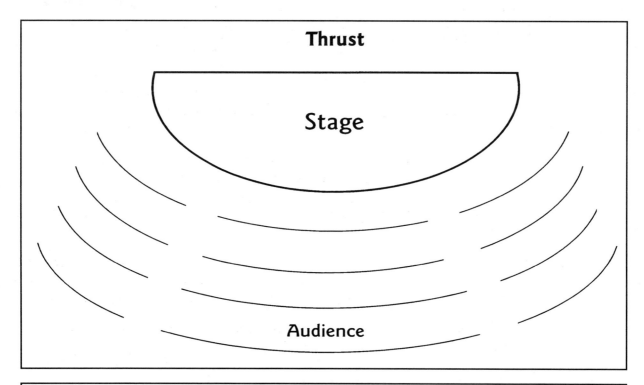

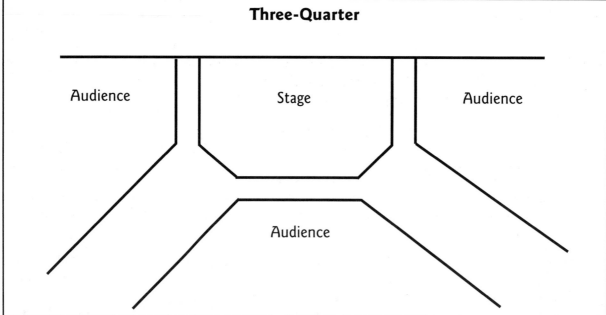

Figure 2 and 3. Thrust/Three-Quarters
The fourth wall is not a straight line but curves. Securing acceptable wing space can be challenging. Most major scenic design elements need to be limited to the upstage area. This format is more intimate but a large percentage of the audience is unable to view the actor's face at any given moment in the performance.

ARENA style, or IN-THE-ROUND, is where the audience surrounds the stage entirely. Arena is ideal for athletics, such as boxing and basketball, but this is a particularly challenging theatrical playing space. The scenery must be minimal and the action of the play has to be 360 degrees so that all of the audience feels a part of the production. But any empty space—ballroom, outdoor lawn, garage—can easily be adjusted to an arena-style theater setting. Place the action in the middle and chairs all around. No platforms or formal stage, or seating risers are necessary.

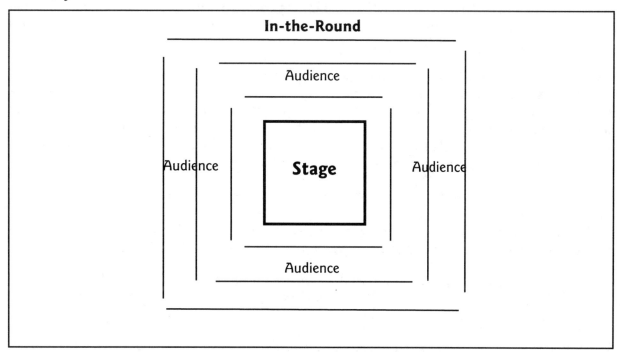

Figure 4. In-The-Round Arena
Major scenery is not possible in this format because it would obstruct views of the stage. Shows with large casts are also challenging in this format because the bodies can obstruct views.

The final structure is called ENVIRONMENTAL where the action of the play happens all around you. A recent Broadway revival of Cabaret was held at Studio 54 where the audience space was set up like an actual cabaret. This kind of structure involves the audience and usually means a lot of turning of the neck to watch the action.

When you go to shows, observe what the structure of the theater is—proscenium, thrust, arena, or environmental. Secondly, observe how the production utilizes the theater's wings space, crossovers, or fly space.

The dimension of the space also has an impact on the experience of the show. For example, if the theater is old versus new, or if the seating capacity is large versus small. Madison Square Garden has a theater that seats almost 6,000 people. Radio City Music Hall does seat 6,000 but people are astonished that there's only a 400-seat difference. The Music Hall is very lofty and grandeur with several mezzanines—you get a definite sense of space, while MSG has an amphitheater look with no balconies. It's very intimate—well, as intimate as you can be for 5,600 people.

Another example of how the space affects the show is the Nederlander Theater on 41st Street in New York. Prior to the renovation of 42nd Street and Times Square, 41st St. wasn't a desirable place, and it was difficult for that theater to sustain a hit show. That is until *Rent* opened there. The story about a Bohemian artist in the East Village is the perfect subject matter for that theater.

Climate control and the theater's HVAC unit can impact greatly on a show. On numerous occasions, shivering during a production or fanning myself with the Playbill to stay cool has affected my experience. When a theater is cold, it's difficult for comedy to have a strong impact. The performers are literally playing to a cold audience.

Most curtain times are 8:00 P.M. (although Broadway has started a Kid's Night On Broadway for Tuesday evenings where shows start at 7 P.M.). And most theater patrons will dine at a restaurant prior to curtain. This is great for restaurant commerce and people seem to enjoy the pre-show dining experience, but you must keep one thing in mind—people tend to get sleepy on a full stomach. Caution: watch the quantity of in-take and have a cup of coffee or a Coke after your meal. If the play is a dud, well, you don't want to snore too loudly.

It's also important to examine the people around you. They make up the audience, so take a moment to observe them—who are they? Do they possess the same attitudes and values as you? What about age? Gender? Why are they there? Do you think a large portion of them came because they wanted to, or they came along because they were invited?

Thanks to hip-hop entrepreneurs Russell Simmons, producer of *Def Poetry Jam*, and Sean "Puffy" Combs, performer in a revival of *A Raisin In The Sun*, a new generation of theater goers was recently introduced to Broadway.

When I worked on the show, *The Lion King*, it was always thrilling for me to observe children in the audience. It was magical to stand in the wings and look out in the house and see their smiling faces—a reflection of the pure joy of childhood innocence.

🎭 Active or Passive 🎭

List a few shows that you have seen and indicate whether your experience was an active one or a passive one.

Show: _____ _____ Active _____ Passive

Why? _____

Show: _____ _____ Active _____ Passive

Why? _____

Show: _____ _____ Active _____ Passive

Why? _____

Show: _____ _____ Active _____ Passive

Why? _____

Show: _____ _____ Active _____ Passive

Why? _____

Show: _____ _____ Active _____ Passive

Why? _____

Part II

The Creators

The Playwright

Ever wonder why playwright is not spelled playwrite? W.R.I.T.E. Seemingly, "screenwriter" is spelled the right way using the noun form of the verb write. Why not playwright, or playwrite?

Well, playwrights have certainly been around longer than screenwriters. It's spelled that way because in old English a "wright" is someone who molds, shapes or repairs something. (Think: iron wrought) So a playwright is a molder and shaper of plays.

And a playwright's real work begins once the script has been written. He must re-write and re-write new versions and new drafts.

Compared to writing in other mediums like television and film, a playwright enjoys great autonomy and has much more rights of authorship. For example, a playwright owns the copyright to his work so he, and he alone, decides how the property will be used. Playwrights must receive appropriate billing and credit because in most circumstances, contractually their name must appear with the title usually at least one-third the size of the title, (quick: name a screen writer?). However, typically playwriting is not a financially lucrative field, with the exception of a very small minority. It is extremely difficult to earn a satisfactory living on playwriting alone; playwrights usually supplement stage royalties with writing for film and television.

Playwrights Before Screenwriters

- Alan Ball—*American Beauty; Six Feet Under*

- David Mamet—*The Postman Always Rings Twice; The Untouchables* (Academy Award)

- Patrick Marber—*Closer*

- Allan Knee—*Finding Neverland*

A television series will normally employ up to a dozen writers. Some TV shows will assign specific writers to characters and then the scripts are collectively written.

In movies, many others such as artsy-fartsy directors, nervous studio executives, and temperamental stars often alter and change the script during the filming process. Until recently, screenwriters weren't even allowed on the movie set. The motion picture studio owns the copyright and the author falls under the legal guise as a "work for hire." However, writers in TV or film certainly earn sufficient wages.

For example, a writer for a typical Movie of the Week receives approximately $150,000. For a screenplay for a feature film, a writer receives $500,000. On the other hand, a playwright receives approximately two points of the net ticket sales of his Broadway show; and that's assuming, of course, that the play actually gets produced.

Before the production occurs, a playwright usually takes his script through a series of drafts—sometimes as little as two or three, and other times as many as a dozen. It's often said that once the play is written, now the work begins (in the form of re-writes).

Sometimes, playwrights work with a dramaturge, which is similar to a script doctor. The dramaturge provides an objective eye and can force the writer to examine the arch of the story, historical accuracies, character development, and plot structure.

As it relates to theater, the playwright enjoys the unique position as a wholly true creative artist. This is not to diminish the value of other artists in the theater craft but the playwright originates the story—he literally gives birth to it. From that point on, all other creative artists are interpreting the playwright's text—his idea(s). You might say, well, what about when the actor improvs and there is no writer? In that case, the actor is merely serving a dual role as writer and performer. Both writer and actor are essential, but the writer must pre-exist the performer—in other words, something must be created before it can be performed (and interpreted).

The challenge of presenting a well-crafted play to today's audience is daunting. As noted earlier, this is primarily because today's audience is the most sophisticated in the history of mankind. Audiences nowadays have been exposed to a plethora of media. Couple that with the fact that essentially all stories have been told already, then that doesn't leave much room for creativity for today's writers.

Basic Stories

1. Good vs. evil

2. Romance—obstacles preventing romance

3. Underdog triumphing—David vs. Goliath

4. Coming of age story—developing into manhood or womanhood

5. Historical drama—tracing true dramatic events

The five items listed above frame storytelling themes in a nutshell. That is basically it. And as a smart audience of well educated young adults, you have been experiencing stories since you were in the crib.

So, as an audience member, since you've "been there, done that" with regards to stories—why do we continue to watch shows?

The Characters! It's all about the characters. What distinguish good stories are the characters, even though the stories aren't original. Whether the story takes place in the western frontier of a young America (spaghetti westerns) or in a galaxy far, far away (*Star Wars*), the characters that inhabit the good vs. evil story are the compelling force. Examine the romantic story, the venue switches from Verona (Shakespeare's *Romeo and Juliet*) to the west side of Manhattan (Tony and Maria of *West Side Story*).

As you experience plays, determine which of the five basic stories is being told, then analyze the characters to determine if they are indeed compelling and resonating, or are they just ordinary.

To achieve a well-crafted story with compelling characters, the playwright has several tools at his disposal. There are three basic ones—action, dialogue, and world construction.

Action—the backbone of a well-crafted script. Something must happen to the characters. And they should **do** something, and not just talk about it. Hamlet's father was murdered by his uncle. He wants revenge. That's action. In *West Side Story*, Tony falls in love with Maria, and is prepared to betray his friendships to get her. That's action. Remember—show, don't tell.

When you see plays, try to examine the action of the play—both as it relates to the story and the characters—simply what are they doing (belittling, amusing) and what they want (forget the past, succeed in life, etc.).

Playwriting 101

A simple writing exercise issued to students in most reputable playwriting programs is to write a short, five-minute play without any spoken dialogue. This forces the writer to create action without relying and depending on dialogue.

Example:

Man sits at kitchen table reading the newspaper ignoring his wife who is annoyed at his ambivalence. The water pot boils. The wife goes to the stove, picks up the tea kettle. The husband holds the coffee cup for the wife to pour while he still reads the newspaper. She pours the hot water on his lap.

Total action, no dialogue. And if you are able to envision the action of this scene in your mind, then it's quite possible to grasp what's happening without a lot of dialogue.

Dialogue—at first glance, writing what the character actually says might seem very easy to construct, but it is very tricky to do well. Well-crafted dialogue should definitely be from the character's point-of-view—in his or her words and as only they can say it. And it must spring from the action of the scene.

Good dialogue is designed to achieve at least one of two things (but sometimes both):

1. Further define the character

2. Advance the plot

Usually if neither of these items is occurring, the scene becomes superfluous. In other words, the scene could be removed and your experience as an audience member would not suffer in the least. Plus, given the attention span of today's youthful audiences, this should not be looked upon as a good thing.

Analyzing Dialogue

"I've never been sick a day in my life. I ain't goin' to no doctor!"

We can derive a lot from this line. Is the character in solid physical health or is she lying? This would be set up by her appearance. The actor might make choices to be physically weak and in denial about her condition.

She uses incorrect grammar, so her educational level probably isn't that high. And the plot's advanced because she's setting up that she is refusing to go to the doctor.

Some playwrights are masterful at creating stimulating dialogue as the words just spill from the characters' mouths in poetic fashion. Some poignant examples:

✓ Harold Pinter who deftly uses the lack of dialogue (pauses) as an effective writing device.

✓ Tennessee Williams, his characters speak with lyrical southern drawls fitted with creative analogies and colloquialisms.

✓ David Mamet whose dialogue contains poetically placed expletives. He made curse words artistry.

✓ August Wilson places extensive monologues in the middle of his plays—monologues pack such an emotional punch and are extremely lyrical. Due to their length and emotional depth, they are very challenging to the actor.

Plausible World—the final tool that good playwrights display is the construction and creation of a plausible world. The playwright has to establish the setting, the mood, the pacing of the characters. He has to decide what to reveal and when to reveal it.

This is challenging to achieve on stage, more so than film because of so many limitations of live theater. None-the-less, in order for the play to function creatively, the audience has to believe that the world the playwright's characters inhabit exists.

For example, it is very difficult to reveal a car crash on stage, but this has been done countless times in movies. The crafty playwright must use writing techniques to get the audience to comprehend the emotional impact of a car crash that they didn't observe. Showing the aftermath in the hospital waiting room can do this, or seeing a once healthy a vibrant character pushed on stage in a wheelchair. Selecting these scenes all goes into establishing a plausible world, which helps to create a dramatic story worth telling.

The basic dramatic writing structure of a play can be divided into three separate parts. This analysis greatly over-simplifies the craft of playwriting but it will allow you to begin to appreciate the foundation of well-crafted storytelling. The structure of a play can be divided into three different areas/sections:

- ✓ Set-Up

- ✓ Conflict

- ✓ Resolution

The **Set-Up** establishes in specific terms. WHO the characters are and just as important, the world in which these characters live. The importance of a competent "set-up" cannot be over empathized. This function is critical because the main purpose of set-up is to establish empathy for the characters.

If the audience doesn't/can't/won't emphasize with the characters, it is exceedingly difficult to want to travel on their journey. Empathy creates, for the audience, an emotional investment in the characters. You, as the audience, can identify with their struggles, their plights and their hopes and desires. And the good play creates all of this in the first opening moments of the play.

Opening Scene

Set-Up Scenario #1—opening scene—a man walks into a room, another man follows. The second man starts pummeling the first man. Where does your empathy lie? This convolutes your choices of how you decide who to emphasize with. If one man is shorter, do you empathize with him because he's at a physical disadvantage? Do you like one's clothes better than the other? So you can see how the craftsmanship in this Set-Up is poor.

Set-Up Scenario #2—opening scene—a man walks into a room, and throws his keys on the table, which a fair assumption is that he has entered his home. The second man enters, and starts pummeling the first man. You might then assume that the second man is an intruder, thereby causing you to empathize more with the first man. See how this scenario is better crafted than the first. However, this story is still not very compelling or well-established.

Set-Up Scenario #3—opening scene—man enters throwing his keys on the table, but then turns on his telephone answering machine. A message is heard from his fiancée saying she is calling off the wedding and is eloping with his best friend. Now, the second man enters wearing a facial mask. He starts attacking the poor guy who just got jilted. This particular set-up is more compelling because the first character now has more depth. The audience can more readily empathize with his situation.

Better technique and craftsmanship equates to a better story.

The vast majority of script problems can be traced back to how well the playwright has set-up the story.

Character set-up is always more effective when it results from the character's action as opposed to exposition and dialogue. For example, it can be said in the dialogue that a character is really funny but it's far more powerful for the audience to actually experience how funny the character is. This approach is more effective because the *act of doing* carries more dramatic power, rather than just hearing about it, which is called "exposition."

The set-up portion of the text is so important because it accomplishes two major goals:

1. Defines the character (s).

2. Establishes empathy for the character(s).

Defining the character allows the audience to identify with the character. His or her personality and characteristics are exemplified. We then get to see the character's goals and objectives. In all well-crafted plays, the characters have objectives—in *West Side Story*, Tony's objective is to be with Maria while in *Hamlet*, the young prince wants to avenge his father's murder.

Once character has been more or less defined during the beginning moments of the play, empathy for that character is established. This function is critical because it correlates directly to the next component of script structure—**conflict**.

Empathy for the characters occurs first during the Set-Up as the audience determines the wants and desires of character(s). Once these "objectives" are clearly defined, the next step is to put an obstacle, or obstacles, in the way of the objective. This is called the "conflict" which is the fundamental basis for drama. Without a conflict, there is no drama.

Hey, imagine in *West Side Story*, the Jets and the Sharks decide feuding over race and conducting their gang war is no longer desirable. So, of course, our star-crossed lovers Tony and Maria get married and live happily ever after. Well, the play would be over pretty quickly, and I'd venture to say it would be a tad less appetizing.

As a general rule, the more challenging the conflict, the more compelling the story usually is. When the stakes are high, coping with life-and-death consequences, the dramatic tension is increased, thus, the audience becomes more engaged. Also, when the stakes are considerably higher, the conflicts (adversaries) creating these obstacles must also be considerably significant—in other words, they should be a worthy opponent.

Also, well-crafted scripts have more than one conflict as the characters face both internal and external conflicts. Hamlet seeks revenge for the killing of his father, but to merely kill Claudius would also mean making Gertrude, Hamlet's mother who married his Uncle, a widow once more.

In *West Side Story*, Tony must cope with his own feelings of betrayal because he no longer wants to be a part of the gang. Bernardo, leader of the Puerto Rican gang, is not just a random hooligan, but the brother of Maria, the girl that Tony loves.

The playwright should be mindful not to make the stakes so insurmountable that the story becomes excess. That style is labeled as melodramatic.

Impetus

What compels a playwright to share his/her story with an audience?

What is the significance of the telling that story?

And what inspires him or her to write a play?

We call this inspirational impulse to write an impetus, an instinctive desire that propels the writer to the computer (or typewriter). The impetus sparks the journey of writing a play, where turning sheets of blank white pages into a story of dialogue, that will eventually entertain, enlighten, and educate audiences.

Trying to ascertain the playwright's impetus is a challenging yet worthwhile charge. Discovering the writer's impetus allows the audience an intimate peek into the writer's thought pattern while providing an enhanced view of the play.

Anna in the Tropics

Young, Cuban-American playwright, Nilo Cruz, won the 2003 Pulitzer Prize for his play, *Anna In The Tropics*, which is set in a 1929 Florida in a cigar factory on the brink of changing over to automation. The old-style factory owner employs a reader, or "lector," who simply reads—newspapers,

novels, Shakespeare—to the workers to educate the workers and pass the time during the day. In the play, the book of choice for the lector is Leo Tolstoy's "Anna Karenina." The reading of this classic novel has obvious parallels to the workers' lives and leads to explosive consequences.

The impetus for Cruz to write this play was to illustrate how the impact of reading a novel can change your life. This concept was cleverly dramatized in play.

The final component of a well-crafted script is **resolution** which is how the conflict is resolved. Note the key here is REsolved, not solved. The complexity of the human experience does not usually allow for endings where everyone "lives happily ever after." Life is more complicated than that. This approach might be useful for the bedtime stories of preschoolers but as an effective dramatic technique it is viewed as overly simplistic.

A good resolution to a script provides a satisfactory conclusion that has a degree of logic and rationality.

Several parallels have been made between Shakespeare's *Romeo and Juliet* and the Broadway musical *West Side Story* (even in this book). But it's fascinating to observe the differences in the respective resolutions. This speaks volumes about the societal differences of modern times and Shakespeare's Elizabethan period.

The story of *Romeo and Juliet* resolved with the suicidal deaths of the young lovers; however, *West Side Story* does not conclude with any suicides. Perhaps the authors of *West Side Story* viewed 20th century society as too sophisticated to believe that a woman would take her life over the tragic and unfortunate violent death of her man.

A good resolution also provides closure to the story but will force you to ask more questions and further examine the play's subject matter. As an audience member, a crafted resolution should make you feel satisfied. You walk out of the theater feeling that the journey you experienced with the characters is complete, but you also continue to examine the topic. You scrutinize your own experiences and viewpoints about the subject matter. You might even do further study. When this happens, the playwright has done his job well.

Advance Playwright Techniques

See if you can observe any of the techniques listed below when you attend plays:

Names—most of the time are not arbitrary, but deliberately selected. When you go to plays, examine the character's names and try to discern if the writer gave the characters their names for a particular reason.

> *Foreshadowing*—precursor to future events. A good example of foreshadowing is the opening scene in the classic movie *The Wizard of Oz*. Pay close attention to the scenes with the farmhands who will later be the Scarecrow, Tinman, and Lion. The workers respectively encourage Dorothy to be brave, to be smart, and to have a heart.
>
> *Paradox*—always an effective tool that audiences appreciate—unexpected contradiction. Audiences are always thrilled with this technique, often accompanied with "you'll never guess what happens!"

Apply some of the techniques discussed in this chapter to some of your own stories. Utilize the set-up, conflict, and resolution to see if your story becomes more engaging. Hey, you never know, maybe it can serve as the genesis to a new prize-winning play! It could lead you to the impetus to write a play.

🎭 Playwright/Storytelling 🎭

Use the story you detailed in the earlier chapter to answer the questions below.

What is the title of your story? _____

Name the main character: _____

Set-Up—how will you establish empathy for this character?

What is/are the objectives of your main character?

External Conflict. _____

Internal Conflict. _____

How is your story resolved? _____

 # The Actor

"Acting is easy."

That seems to be the general consensus if you chronicle the rock stars, star athletes, rap stars, and reality-show winners attempting to pursue an acting career.

Let's do a quick survey...say the conductor of the New York Philharmonic is coming to campus to audition trained musicians to play in the symphony. How many students would audition? A few of you....

Now, let's say Judith Jameson, the choreographer for the world renowned Alvin Ailey American Dance Theater, is coming to campus to audition dancers who are trained in both classical ballet and modern dance technique. How many students would audition? A few more....

Let's say Beverly Sills, former director of the New York City Opera, is looking for young singers who are classically trained and can sight-read for a new opera. How many students would audition? A couple....

Now let's say Steven Spielberg is coming to campus to audition students for an upcoming movie. How many students would come to the audition? Most.

The plethora of students attending Mr. Spielberg's audition probably have acting experience which is limited to a few plays from elementary school days.

Mastering the technique of acting is just as demanding as all the other performing arts but I've always been fascinated by common folk's belief that they naturally possess the skills to act on stage or in film. Obviously acting on stage or movies or TV is not exactly the same as singing at the Met or playing with the Philharmonic—but on all too many occasions, several individuals who lack formal training have had successful acting careers without the professional training and dedication one would believe necessary (the governor of California is one of many examples).

The belief is: Acting is easy. Furthermore, the perception exists that there's a great difference between performing in a play and stroking a violin as part of an orchestra. One seems easier, more natural (acting); and one is not (violin). There's a definite difference.

But is there a difference? Really?

One of the main reasons for this difference of perception is that acting is simply talking and listening. And—Eureka! Most people can do that, talk and listen. However, most people cannot dance on Pointe nor vocally hit a High C.

What's noteworthy is that studying the craft of acting is just as demanding as the other disciplines in the performing arts—dance and music. Like the musicians performing in Carnegie Hall and the ballerinas at Lincoln Center, quality acting requires years of study. Training the voice, working on speech and diction, learning intimately all aspects of your body and its movement, developing improv skills, handling classical text, watching your diet, coping with career management (agents, managers, etc.), and learning stage combat provide a glimpse of the actor's necessary skills.

Former child star Mickey Rooney once said to me "Children make brilliant actors." He said this because the imagination of a child is a beautiful happening due to their innocence. The beauty of innocence is lost when, according to Mr. Rooney, the opposite sex becomes noticeable and desirable. Then the child becomes self-conscious and concerned about his image. Thus, the innocence is gone.

There is a reason that a show is called a *play*. Think about it—an actor is literally *playing* a role. Except for maybe the corporate Halloween party, adults don't dress up in costumes and play characters—but children do.

Much of acting training is based on eliminating the student's self-conscious nature and unlearning a lot of habits deeply rooted in their subconscious. Good actors approach a character in a play with the innocence of a child—not concerned with how they look or what others might say, but rather attacking the role with a strong uncompromising conviction that is fully committed.

Contrary to popular belief, good acting is not putting on a mask but rather taking off a mask to reveal the true emotional reservoir that is stored in us all. Social norms and etiquette have transformed humans into polite social beasts; this is great for the advancement of humankind, but horrendous for the development of an actor. The talented actor is in contact with his/her raw, unfiltered emotional desires, which allows him/her to creatively express the feelings and behavior of the character being portrayed.

Tools of the Actor

Like the painter has his brush, canvas, and paints; the actor has his body, voice, and imagination.

Body

The body has been a part of the actor for his entire life. The talented actor must be intimately aware and sensitive to all parts, facets, and nuances of his body. Most movement training

focuses on the coordination of the whole body for the use of self. Average people retain lots of tension in their bodies, and actor training of the body allows the tension and pressure points to be relaxed. Then, the actor can better mold and define the movement and body expression of the character he is portraying.

As an audience member, observing the actor's body is a powerful visual image. It's what you see mostly, and effectively using this instrument is critical for good character development. When you see shows, note how the actor uses the body to help define the character or communicate behavior. Note behavioral characteristics such as using hand gestures when talking or nervous habits like biting fingernails. Note how the character walks...does the walk appropriately reflect the character's age? Note how body language is used to convey emotions and/or moods.

Voice

If the body is a dominant visual image, the voice provides aural supremacy. Development of good vocal and speech technique is also an essential component for effective acting. Like movement/body work is designed to release tension and stress in the body, vocal technique focuses on releasing tension and stress in the voice. The training allows the actor to develop good breathing habits so that the voice can project with volume and clarity. Speech work is equally important so that the words the actor is speaking can be understood. Throughout our daily lives, we develop habits that are not helpful to the actor—regionalisms, accents, lazy tongues.

Try this exercise—keeping your lips shut, rotate your tongue in a circular fashion around your mouth (in front of your teeth). Do this for 30 seconds. Hardly-used tongue muscles should begin to be sore. Interesting how many muscles in our bodies that aren't utilized fully. This exercise strengthens the tongue that in turn will provide clearer speech through proper tongue placement.

When you watch performances, note how the actor uses his voice to help define the character and accentuate behavior. Is there a pattern or rhythm to the actor's dialogue? How does the voice convey the actor's mood? Hey, can you hear him/her? (low volume is always frustrating).

Imagination

This tool is one that you can't hear or see, but don't be fooled—it's an extremely valuable tool that you, as an audience member, will never see. An actor uses his imagination to "craft" his character, to explore relationships and circumstances. There's a concept called "back story" where the actor provides detailed information about the character's life prior to the start of the script. Utilizing this skill to its fullest separates great performances from average performances. In establishing a compelling back story, the actor's imagination bring dimension and depth to the character.

Let's say, there's a married couple in the play that have been together for ten years. The actors do their "homework" to craft their marriage—first dates, meeting the parents, flirtation with infidelity. Talented actors create compelling and rich back-stories that add dimension and depth to the characters and their situations.

We defined acting as *"**living truthfully under imaginary circumstances**,"* so the actor must make these circumstances real for himself/herself. Create circumstances that are extreme but yet real—audiences enjoy these kind of performers because this represents the "real" world. Our lives are not simple but based on centuries of socialization coupled with our own individual flaws and frailties. It's always refreshing to witness an actor re-create this truthfully in front of our eyes!

Training

Good training allows the actors to fine-tune the three tools listed above—body, voice, and imagination—so that he/she can deliver a heightened, resonating performance each and every night (or in the case of movies and television, each and every take). In the United States, two basic approaches to achieving solid acting training exist:

1. Conservatory training at an institute for higher education—either on the under-graduate (Bachelor of Fine Arts) or graduate (Masters of Fine Arts) level.

2. Studio training in reputable schools are basically located in New York City or Los Angeles.

(I guess there's a third approach—no training at all. Imagine going into surgery and the doctor operating on you has decided medical school and formal interning is not necessary. How comfortable would you be with that?)

There are dozens of fine collegiate institutions specializing in training of actors where students earn their degree through rigorous training and study with master teachers. These MFA programs are normally three years to complete. Most acting studios offer certificates at the completion of two years of study. No one approach is perfect as there are several reasons to select either option.

Generally speaking, good acting training allows the actor to vividly bring a character to three-dimensional existence by *living truthfully under imaginary circumstances*. It takes a mastery of the technical craft of acting to achieve this. Most training curricula combine rigorous studio class work, coupled with performance opportunities. Performance or performing options are usually more limited with studio training.

The goal of the training is to develop a skillful artist who has the requisite skills to work professionally on stage with both classical and contemporary repertory, as well as adjusting to the diverse acting demands of film and television.

Most recognized training programs focus on the specific study of:

✓ Acting

✓ Voice

✓ Speech

✓ Movement

These four areas constitute the core, as these courses are interwoven each semester to form the foundation of study. Obviously students take more than four classes. Also, good acting programs have equally challenging programs in design (costumes, lighting, scenic) and production (stage management, theater management, technical direction)—this allows the acting students the opportunity to develop along with complimentary craftsmen and artists.

Emotional Reservoir

How come there are showers in the dressing rooms? Outside of a show where performers are dancing and working up a sweat, what's the use of a shower? Aside from wearing hot costumes and performing under thousands of wattage of bright lamps, the actor is emotionally drained at the end of the show. Most major characters will experience a life-time of emotional experiences in the truncated span of two to three hours. The actor, in a matter of minutes, experiences events that occur over the course of several weeks, or maybe months or years in our everyday life. For demanding lead roles, visit a star in the dressing room at the show's conclusion. You will find an artist who is sweating and in need of a shower because his/her emotional reservoir is drained.

Lay people always seem to be amazed that actors are able to memorize lines. Well, when you rehearse a scene over and over and over again everyday for three to six weeks, retaining the words isn't all that difficult.

Another thing that lay people always seem to be amazed at is when an actor cries on stage. That seems to be the primary barometer of an actor's talent. But remember, acting is living truthfully under imaginary circumstances. Part of the training of the actor is to develop the necessary skills so that when the script calls for emotional situations, the actor brings it to life—whether that means crying, or laughing or expressing anger.

Different acting styles use different techniques for this. Some encourage the use of substitution—which advocates "substituting" circumstances in the script with the actor's real life occurrences. This method can be dangerous because a tendency to produce residual effects related to calling upon past emotional situations, particularly if scars from the "substituted" event still remain in the actor's personal life.

Still, another thought relies strongly upon developing external and body movement to express the depth of a character. The actor essentially harnesses his emotions and feelings from the outside in. The use of the Psychological Gesture allows the actor to shape his body and voice to discover and define characters. Some actors find this approach far more liberating than internal or intellectual character analysis.

Actor Training for the Stage

Most conservatory actor training uses stage acting, not acting for the camera, as its basis. Why? Well, producing film and television are costly mediums, so a school would have to invest hundreds of thousands of dollars in expensive cameras and editing equipment.

Plus, the thinking is that living truthfully under imaginary circumstances is most challenging when executed live. Presenting performances in theaters in the schools—either universities or studios—is rather simple.

Differences exist between acting on stage, in film, and on television:

✓ Stage—strong emphasis on vocal quality of voice. Audience in the rear of the theater has to be able to hear. Generally the *actor* has a strong creative impact.

✓ Film—Sixty-foot screen. *Camera* is the dominant resource; therefore the director has the strongest creative impact.

✓ Television—mostly shot from the waste up. It's all about the face. Not as much emphasis placed on the body. Developing characters on a weekly basis over the course of several years means the *Writer/Producer* has the most impact creatively.

Anonymous

Contrary to popular belief, most actors are anonymous. They work in obscurity just like most other professions—teachers, office clerks, auto repairmen, etc. Look up your favorite movies on imdb.com. Probably, on average, you are aware of say a half-dozen of the actors, and most movies list about two dozen principal characters; if you count other roles, such as non-speaking roles and extras, you've witnessed a movie with a few hundred characters. Suffice to say, most of them you are unaware of.

You Are Your Instrument

Another unique and important difference about the field of acting is the fact that you are your instrument—and in most cases, you can't change that. Sure, you can visit a plastic surgeon but essentially, you are who you are—height, weight, bone structure, body mass, personality, etc.

Show business is full of rejection, and when you audition, then get rejected, it's always noted that it's not personal. But guess what? To the actor, to a certain extent, it *is* personal. If you don't appreciate an artist's painting, or a musician's song, that's not a direct reflection on his personality or physicality. But on a regular basis, actors are judged on precisely that—their personality and physical appearance. After a while, it becomes very difficult not to take it personally.

Figure 5. Ashanti Johnson

The main goal of the headshot is to get an audition. That's minimally what an actor can ask for—the opportunity to demonstrate his/her skill. Think of the kind of roles Ashanti would be called to audition for. College roommate, receptionist. You get a fun-loving quality from the head shot. Also, based on her picture, what roles would she NOT be called?

Headshot

An actor's headshot is a vital tool for an actor to secure employment. It presents the actor with an opportunity to "advertise" himself to the decision-makers in the business. A good head shot captures the essential qualities of the actor, and should give the observer a good sense of the *type* of roles the actor could play.

Pursuing a career in acting is a grueling life, and I have a strong admiration for individuals who possess the internal belief and confidence to continue to pursue their dreams in the face of seemingly insurmountable odds. It's extremely admirable.

VAL from *A Chorus Line*

A Broadway revival is in development for the landmark musical, *A Chorus Line*, but no matter where this show is performed—regional theater, community theater, college theater or high school—the "Dance: 10, Looks: 3" number is sure to stop the show.

The actress/dancer, Val, sings about when she took a peek at her audition critique after an audition, and scored for dance: 10, for looks: 3

She then realized that she had to improve her "looks" so she promptly scheduled an appointment with a plastic surgeon to increase her T and A. After the procedure, her career instantly changed as a result of her new bodily enhancements. She got lots of roles and became the envy of her friends.

It's interesting to note that the musical, *A Chorus Line*, was written in the 1970s before the dangers of breast implants were public knowledge. None-the-less, the song is cleverly written and is always an audience-favorite.

The sad reality is that there are simply not enough jobs for all the available talent. As a result, so many talented artists remain unemployed. And there is no way to gauge and regulate the entry of talent. Unlike the medical profession or, say, teaching profession, no tests are required to have access to auditions.

According to the Bureau of Statistics of the US Department of Labor, the median annual earnings of salaried actors were $23,470 in 2002. The middle 50 percent earned between $15,320 and $53,320. The lowest 10 percent earned less than $13,330, and the highest 10 percent earned more than $106,360.

Movie and TV actors with speaking parts earned a minimum daily rate of $678 or $2,352 for a 5-day week as of July 1, 2003. Screen actors also receive contributions to their health and pension plans and additional compensation for reruns and foreign telecasts of the productions in which they appear.

According to Actors' Equity, the stage performers' union, the minimum weekly salary for actors in Broadway productions as of June 30, 2004 was $1,381. Actors in Off-Broadway theaters received minimums ranging from $493 to $765 a week as of October, 2005, depending on the seating capacity of the theater. Regional theaters that operate under an Equity agreement pay actors $531 to $800 per week. For touring productions, actors receive an additional $111 per day for living expenses ($117 per day in larger, higher cost cities).

Survival Skills

I have several friends and colleagues who earn their living as professional actors. And what amazes me about all of them is their ability to make the most out of any situation regarding their finances and living expenses. They are true optimists as they have an uncanny ability to survive from paycheck to paycheck (and sometimes it can be a rather meager paycheck). They utilize all the skills at their disposal—juggling, singing, teaching, tutoring, and the list goes on and on. I respect their perseverance to continue against some very large odds.

Colleen—Actor in NYC

"Other than collecting unemployment, I have been fortunate. . . . I've only done two non-acting jobs since first pursing a career as an actor as a sophomore in college. The one job I did for almost a whole week before I landed my first Broadway job—it was as an office temp and I worked for Smith and Barney, I think it was. Reception, basic office work, Xeroxing, Faxing, some computer stuff, typing. Entering numbers in.

The other job I did for two days, and that was catering. I did two Seder dinners two days in a row, and made about $250 each evening at a total of about five hours each night. Of course that was including tip, and I got tipped well because I folded the napkins fancy like my sister taught me, and also I cook, so I helped with some of that. This summer, I'll be teaching 3 two-week courses to middle and high school aged kids at a musical theater camp. I've been very fortunate to find work doing what I love. In August, I start on an Off Broadway musical!"

The Director

The temperamental star is having a bad day. Nothing seems to be going right. The person in charge slowly walks over and pulls the star aside. Gently putting an arm around the star, a few encouraging words are whispered in the star's ear. They both look at each other and smile. Then, they get back to work and start over again. This time, quite noticeably, the star's performance has improved.

Did this little exchange take place in a gymnasium or a Broadway rehearsal studio? Well, it could have occurred in either location.

Coaching a team and directing a play are indeed very similar. A major aspect they share is the idea of motivation. Actors must be challenged and motivated—pushed to discover insight(s) about the character to enhance its being. Other similarities include emphasizing the importance of teamwork, conducting try-outs and auditions, and running rehearsals vs. practices.

Similarities of Job Descriptions

	Coach	Director
Teamwork	players working together	actors working together
Leadership	design game plans	develops show concept
Hiring	try-outs	auditions
Management	efficient practices	efficient rehearsals

The foremost function of a director of plays is to add creative dimension to the script by vividly bringing it to life. He takes the playwright's words and actions to create a three dimensional world on stage. He is also responsible for coordinating all aspects of the creative

functions of the production—the actors, the designers, the technicians, etc. A major objective is supervising and unifying all creative phases of the play.

It's important to note that the specific use of a director is a 20th century development. Historically, playwrights and actors essentially 'directed' themselves. Also, advances in technology in the early 20th century (lighting, automated scene design, etc.) increased the need for an objective third eye.

The director's work starts with the ***concept***, which is the unifying vision of the play.

When a director interprets a script, in his mind's eye he sees the actors entering and exiting; he sees them in costume, moving through space. It's as if he has a video screen in his mind which visualizes a fully realized production.

To the average audience, it's exceedingly difficult to ascertain the value of the director's contributions. However, we'll examine a few basic aspects of his function that are very important, which in turn will enhance your appreciation of the task of the director.

One of his beginning functions is to develop a visual metaphor for the script. This "controlling idea" is a part of his overall "**concept**" of the show and serves as the creative backbone, or "spine," of the production. The impact of the visual metaphor should ideally unite all the creative and technical aspects of the production.

For example, a director decides that his concept for *Hamlet* is to position the production like a prison—to show that Hamlet is trapped, physically and metaphorically behind bars. This visual image can then be executed on several levels. The scenic design could incorporate lots of vertical lines similar to prison bars. The lighting design could be dark and shadowy. The costumes could be a dull gray, or maybe even use the style of the colorful prison jump suits. The designers working on the production appreciate the unifying concept—it allows them to have a "limited freedom" to explore creative options.

All concepts should be derived from the true spirit of the text. Sometimes, directors can be more intent on displaying their own originality than capturing the essence and meaning of the original playwright's vision. This is particularly true of classical works (whose authors are dead) where the productions have been placed in outer space.

Casting the Show

Without question, casting is the single most important function of the director. It cannot be overemphasized how critical it is to select the appropriate actor(s). Successful casting is the lifeblood of the director. Thus, talented directors recognize the value of the audition process and employ precision-sharp techniques to ensure that the perfect artist is cast for each role, every time.

Unfortunately, a strange paradox exists in the whole auditioning process. This is because at that point, the director is making the most critical decisions about the production; yet he knows the least about the actor (assuming, of course, that the director hasn't worked with the actor before). That's the time when it would behoove the director to know the most information about the actor who is about to be hired.

Location, Location, Location

It's universally known that the three important keys to successful real estate ventures are:

1. Location
2. Location
3. Location

Well, our business has three important keys to a successful production:

1. Casting
2. Casting
3. Casting

Yes, casting **IS** that important! Absolutely.

Most directors usually have very clear ideas in their mind of how they see the characters in the script. The directors can visualize the physical appearance of the characters in their mind's eye—picturing the physical structure of the various characters and visualizing such character aspects as height (tall or short) and build (slender or thick).

While auditioning, directors also have *qualities* of the character in mind. No matter how skillful an actor is, their characters become endowed with the qualities of their essential personality (particularly early on in the audition process). Unlike physical attributes, these personal qualities are very subjective and hard to define. For example, say the director is looking to cast a tough female police officer, and he wants to offer an actress who has a lot of motherly qualities. You might not perceive of a motherly type as being authoritative, but the director does. It's these kinds of differing interpretations that make casting so challenging.

A director's vision of the character is written in what the show business industry calls "character breakdowns"—which details specifically the kinds and types of actors the director is looking for.

Here's hypothetical breakdown for Tony and Maria of *West Side Story*:

Character Breakdown

Tony

20's; Caucasian. Tall (+ 6 feet); Singer (tenor) accomplished dancer (modern, jazz); Attractive. Strong physical presence; Innocent; Idealistic, warm and good natured. Stage combat, a plus.

Maria

20's; Latina: good voice—soprano; dancing (modern, jazz). Young, innocent and naïve, but has strong inner confidence.

A good breakdown captures the essence of the director's vision for the character, and this becomes useful information for the actor when auditioning.

Design Process

Through the director's concept, the designers—scenic, costumes, lighting, and sound—are inspired to use the concept as a creative catalyst in their respective mediums. It is essential that during the planning stages of the design process, the director meets with his designers and communicates clearly how the vision will be realized.

What are the goals and objectives of the show/script?...But most importantly, it is imperative to get all of the creative artists on the same page—all agreeing to work within the same creative parameters.

Usually, these meetings are conducted months (and sometimes years) in advance of the first rehearsal.

Since the environment of the theater is so critical to a stage production, the show's design elements play an important role. The goal is to establish a world for the actor—an environment for him/her that is believable and genuine.

Rehearsal Management

One of the director's main responsibilities is to provide a productive climate where the actor can optimally work. Good directors recognize the value of conducting smooth and efficient rehearsals. Ask any actor and they will inform you that the most frustrating instances occur when they are called for rehearsal and end up sitting around for hours before actually getting to work. Usually, although not all the time, this is a direct reflection of the preparedness (or lack thereof) of the director.

The general mood of the rehearsal process is also an important consideration. Is there seriousness to the climate of rehearsals or does the director keep things light and easy? Are the actors treated with respect of artists, or are they viewed as recyclable talent that should be lucky they have a job? These are important matters in setting the tone for rehearsals because the condition of the rehearsal process is a significant determinant in the resulting quality of the production.

Must Haves

Another responsibility of a director is to define a script's "must haves." These are simply necessary major elements in casting, design, and/or production that the director must have in order for the production to be realized according to his vision. All shows have several must-haves, some are more vital than others.

An example of a 'must have' is seen in the musical *Ragtime*. A central element of the show is a spanking brand new Model T Ford, which is owned by an African American musician around the turn of the century. In the play a few rogue fire fighters damage and vandalize the automobile.

In the Broadway version, it was clear that actually displaying the auto functioning on stage was a Must Have, with the musician proudly driving the vehicle on stage. The racist firemen vandalize the car, and this is witnessed on stage. Then, there's more impact because the audience has actually observed characters interacting with the car. The musician's resulting rampage becomes more readily to empathize.

Director's Tools

Blocking

There are several techniques available to a director to ultimately bring the play script to three-dimensional life. One of the main techniques at his/her disposal is blocking, which is merely the pre-set movement of the actors. When the actors enter and when they exit; stand, move, and cross. All of these movements make up the blocking of the show.

Good directors understand that a well-blocked scene can heighten the scene's dramatic impact. For example, a character is home after a tough day at work. The phone rings. The director could have the actor hurry to drink a shot of alcohol before answering the phone. The drama of the moment can be enhanced because the director can have the actor use the satisfaction of gulping a stiff drink before he crosses to answer the phone.

Business

Business occurs when the director has the actors actually physically doing active things like ironing, folding clothes, smoking, etc. All of these examples allow the actor to further define character as well as giving the character more depth. In our previous example, let's say that our hard working man who had a tough day accidentally dropped his glass of alcohol into the wastebasket. The phone is ringing but he really wants a swig of scotch before answering the phone. The director has the actor pull the glass out of the wastebasket but it's filled with gunk. So the actor decides to just drink from the bottle. And when he answers the telephone, he could then give a loud belch.

Talented actors delight in working with directors who give "direction" like above. This allows the actor to explore little moments of a character which provide great assistance to creating a full-dimensional character. In fact, talented actors can add even more dimension than the director originally had in mind. For instance, while rehearsing the above scene, the actor discovers new moments, such as pulling the glass out of the wastebasket, and then smelling it. He makes a putrid face. Then he reaches in the basket and pulls out a used baby diaper. Thus, taking a swig from the bottle has even more meaning (getting relief from baby poopie). Assigning actors business is a very effective approach to vividly bringing a scene to life so that it resonates beyond the words written in the script.

Staging

The overall look and feel of the production is called staging. It comprises not only the blocking and business, but how other elements of the show, such as lights and music, come together. For example, the fading of lights at the beginning and end of scenes; selection of music played during the beginning while the audience is first filing in, or the pacing of scenery changes in between scenes are all examples of the director's staging.

Objective Third Eye

Finally, good directors are able to maintain an objective third eye in order to insure the various components of the show—actors, designers, and technicians—are operating to their fullest creative and artistic potential. They challenge their fellow artists to push deeper and deeper—to reach their creative potential.

Kittle-speak

Kevin Kittle, stage director, with dozens of credits in NYC, who has worked with Sam Shepard, Joseph Chaikin, and Arthur Miller.

Why do I direct? … well, it comes down to telling stories. I love examining the bigger picture. I mean, we all make a distinction between professional theater and community theater. Well, all theater is community theater!! Actors and audience are all in one room to explore each other. There's an energy between the actor on stage and the audience—it goes back and forth.

My job as a director is to have the story and everything about it go back to the play and the playwright. It's the director's job to explore what the playwright is trying to say in the play. We catch the meaning in what he's trying to say, and we make it actual. It's our job to find the stage equivalent of what he's written on the page. In each play we have to find the primary elements that the playwright is using and how to serve that. We're unifying the whole production—sets, costume, lights, casting—so that the audience has a vicarious experience.

As a director, you're an interpretative artist so you don't want to impose your will. If a director has something to say that much, he should go write his own play. That ain't directing.

 # The Designers

A picture is worth a thousand words.

I have no idea who originally made this statement. Probably an art history professor.

In any event, you've probably heard this old cliché before. It simply means that a picture can be very descriptive, in fact, even more descriptive than words. As an observer of a picture, your mind processes information contained in the picture far faster than reading a one thousand word essay about the picture. Processing visual images stimulates sensations in your mind and heart that go beyond vocabulary.

Picture, if you will, a picture—you're in kindergarten with your two front teeth missing. You're in your back yard playing with your pet dog. This Kodak moment tells a story. Picture the clothes you were wearing, how the backyard was landscaped, notice the toys and balls that litter the back yard. All of those little instances and details added together equate to the big picture—and the describing the details of that picture could take one thousand words.

It's amazing to consider how fast our brains process this kind of information and even more fascinating to consider that this process occurs subconsciously at blinding speed. Our mind develops impressions about certain instances and our brains haven't really fully articulated the impressions. However, these impressions are captured and stored in detail without consciously drawing attention. They occur subtly.

This is the goal of theatrical designers—to subtly create impressions through the use of visual images. These images are the counter-parts of everyday life and they create the visual expressions of a script. They also represent the physical manifestation of story and character which ultimately is the visualization of the director's concept.

We will examine four main design areas: scenic, costumes, lights and sound. Because of sophisticated technical demands, certain productions may require more than these four design elements such as props, projection, and special effects (such as Flying). But most productions at least utilize the aforementioned four main areas.

Scenic Design

Also called the "set design." This design is usually the starting point of the design process. This is because the set design is the environment for the play and all of the other design elements compliment it. A good scenic designer will take the playwright's text and director's concept for that text and create a physical world, which the actors inhabit.

Early in the process, the director and the designer meet to share initial ideas about the script. During these initial discussions, concepts and ideas about the show are shared but also practical matters about the text are considered. They include items like entrances and exits, scene changes, stylistic concerns, and specific script references—all very important matters that might impact the overall design.

No two designers approach the creative process exactly the same, but generally speaking these early meetings with the director inspire the designer to draw thumbnail sketches. These quick drawings allow the designer to get feedback from the director without investing a lot of time in the sketches.

After the director has accepted the designer's preliminary sketches, the next stage involves preparing color renderings. These drawings are more detailed than the sketches and involve perspective and color patterns. These drawings allow the director, as well as the other designers, the opportunity to get an enhanced view of the scenic vision.

Final step is the making of the model. Most directors enjoy seeing their visions manifested in three-dimensional form. Other members of the design team (lights and costumes) look forward to observing the model as well. A model of the scenic design adds perspective and viewpoints that cannot be fully realized in a rendering. For instance, you can see how tall items are in proportion to other scenic elements. You can even take a flash light and get a sense of how certain elements will be lit.

Technical drawings are also prepared. These are detailed mechanical drawings of the set. These draftings are illustrated so that the set can be built and constructed accordingly. The drawings are similar to blue prints created by architects because the same kind of attention to detail must be adhered to in order for the set design to fully function.

Objectives of Good Scenic Design

1. Creating an effective environment for the performer. A good set is like a playground for the actor. Not in a literal sense, but as an audience member you should feel that the performers are comfortable in the environment. Also as if the set itself is an additional character.

2. Set the mood and style. This objective is part-and-parcel with the director's concept and should be derived from the script.

3. Cover the basics—establish locale and time period.

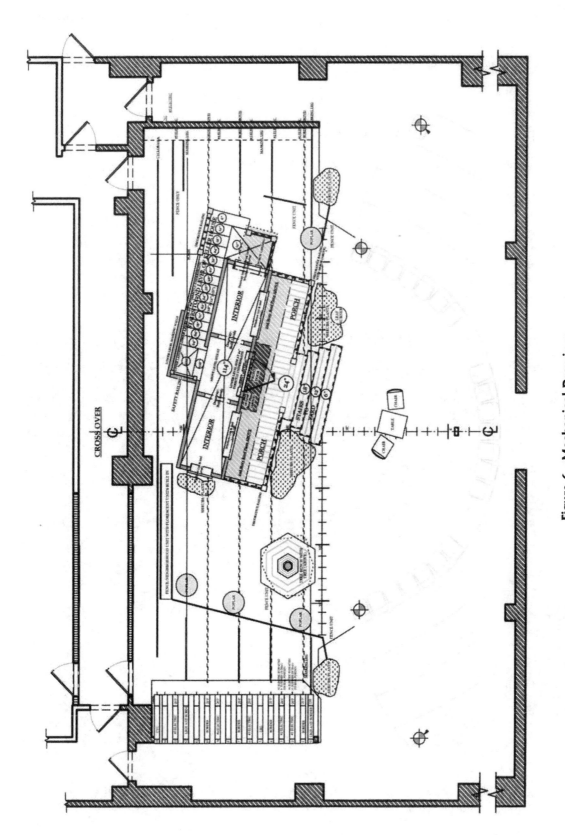

Figure 6. Mechanical Drawings

The ground plan, mechanical drawing of a set design of *All My Sons*, designed by Samuel E. Wright (drafted by Jen Price) and presented at the Crossroads Theater in New Jersey. This detail gives the technical director the specifics so that the set can be constructed.

The designer has a lot of tools at his disposal to accomplish the objectives above. Examples include:

✓ The effective use of color palette—shadings and contrasts.

✓ Textures to establish "feel"—chrome or glass; brick or burlap.

✓ Shapes/patterns—curves, angles, outlines, silhouettes.

✓ Mass/Composition—use of height, weight, bare or light.

✓ Placement of entrances and exits for the performers.

Because movies can capture realistic elements much better, an effective use of creative scenic design occurs when the audience's imagination is challenged. Oftentimes, set designs on the Broadway stage as well as some of the country's leading regional theaters employ sets using a series of sophisticated automated and technical wizardry. However, sometimes the best approach is to KISS (Keep It Simple, Stupid).

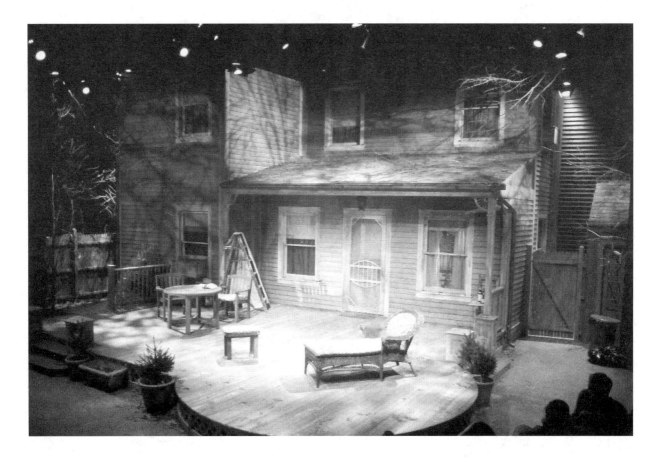

Figure 7. Proof
Scenic designer, Michael Miller, which was presented at the George Street Playhouse, in New Brunswick, N.J. This play is about a mathematician, so examine the set and note the use of geometric shapes through out the design.

Costume Design

Audiences have a tendency to under-appreciate costumes unless the production is a period selection where, say, turn-of-the-century dresses and the like are worn. On the contrary, as you will see, contemporary costuming is equally as challenging to design.

Costuming is a very personal aspect of the creative design process because the actors wear the clothes—and a wardrobe is an extremely personal facet of life. A good many actors have very definitive ideas about their character's appearance. They also develop ideas about which colors work best with their features, how their character selects style of clothes, and of course, the dreaded "this makes me look fat!" interpretation.

It's important to keep in mind however, that it's not the actor who is represented on stage—it's the character. And presumably the costume designer and the director have worked long and hard to conclude which clothing best represents that character.

The influence of clothing is fascinating. Think about playing dress up as a kid and how much fun that was. How your imagination soared to new heights as your body took on a new persona as you walked around the house in your parent's clothes. Think about how some clothes make you feel tougher, some more feminine, and some more intelligent.

Examine your own closet and drawers. Most of the items in there were not arbitrary choices. There are a myriad of reasons why you own them—fashionable, comfortable, color-scheme, reasonably priced.

Look at the clothes you are wearing now. There are reasons why you are dressed that way. The amount of time you spend deciding which garments to wear is certainly relative, but deeply subconscious. There is a definite reason why one character chooses to wear Levi's and the other Lee's. Or Nike's rather than Reeboks.

Do a little internal psychoanalysis and ask yourself these questions? As a consumer, why do you make certain garment selections? During rehearsals, these factors about the characters are sometimes articulated and discussed with the actors. Thus, to the audience, the performer and their costumes should be perceived as one—merged into a single image on stage.

The stages of the costume design process are similar to the scenic design, which starts early on with meetings with the director. After there is some clarity on the scenic design, the costumer can then get to work. Armed with the concept and with a working knowledge of the scenic colors and composition, she begins to draw quick sketches of some preliminary costume ideas. Instead of drawing, some designers will research photographs to give the director costume ideas.

If the show is a "period" production—taking place in the past—extensive research needs to be done in order to insure design integrity. Styles and fashions change so quickly, a play that takes place merely five years ago needs to be researched accordingly.

1970s

Talk to Costume Designers, and one of their favorite periods to design for is the 1970s (my teenage years!). The wild colors and hair styles of the time seem to just inspire a volcano of creativity. You watch a TV show on cable from that time period and you just think "Oh my goodness! People actually wore that stuff!"

I guess I did too, but I was an innocent high school kid. What did I know?

Figure 8. MJ in 1980

OK, this is me in high school at the end of the Disco Era...but look at those designer jeans! And classic Puma sneakers. If you're a designer, you'd have to be thrilled to be hired to dress actors in such hideous clothes.

Whatever style the designer uses, her pencil and drawing pad, the Internet, or magazines, well-crafted costume design has three objectives:

1. Define the character

2. Accentuate the performer's physique

3. Work in tandem with the other design elements (primarily sets and lights)

The first and second objectives are very challenging because they are essentially one in the same. Just like the actor is working to integrate himself as the character, the costume design must do the same—work hand-in-hand to be cohesive.

Define the character. In everyday life when we first meet someone, information is instantly processed about what they're wearing. This is true also when a character walks on stage. From their clothing, we ascertain information like: their social status and position, their sex, occupation, purpose (work or play), and the time period.

Figure 9.
This costume for Jackie Kennedy Onassis, featuring Andrea Reese, was designed by Claudia Montes. With this costume, Ms. Montes' goal was to capture the iconic style of Jackie O. Note the choice of fabric—a pink/peachy soft, sheen. The neckline is accentuated to highlight Jackie's shoulders. It's form-fitting and very feminine. Credit photo, hair, and make-up by Lisa Kapler.

Performer's physique. The actor serves as a "model" so the designer takes the costume rendering and/or photograph to make it three-dimensional based on the actor playing the part. Determining aspects include: actor's height and weight, his/her overall appearance, as well as needs specifically related to the play, such as fight scenes and quick changes.

Figure 10. Rendering

This rendering, sketched by Claudia Montes, is a dance costume, circa 1920s. Notice the fabric swatch illustrates the two different kind of spandex used for the costume. One is tight fitting, while the other is a drapes skirt which will accentuate the performers' dance movements.

Work in tandem. This is critical because scenic color choices and lighting can totally alter the appearance of the costumes. Sometimes, the set and costumes are contrasting colors so that each aspect can stand out accordingly.

> ### Bright White
>
> Because the color white reflects light and lots of lighting instruments are utilized, only on rare occasions should pure white be used on stage. Dying the white a light shade of gray or tan will give, say, a white t-shirt the appearance of being white, without causing the people seated in the first few rows to put on sunglasses.

Pulling vs. Building

There are two basic approaches in obtaining costumes for a production. One is to "pull"—which means the costumer rents clothing from a Costume House. Pulling also can mean purchasing garments at retail stores. And, as a last resort, a designer will use clothes from the actor's wardrobe. This is not allowed on Broadway but is more common Off Broadway and in regional theaters. The Actors' Union has established a set of fees the actors are paid for the rental of their personal belongings.

> ### Shoppers
>
> Wanna design costumes on Broadway?
>
> One popular method to get your foot in the door and climb your way up the ladder is to become a "shopper" which is an entry-level position.
>
> You are armed with a Metrocard for the NYC subway and you're off. Macy's, Sak's, Victoria Secret (the production must supply the actor with skin parts as well as costumes), specialty shops in the Village, all in Manhattan (and sometimes Jersey—no sales tax on clothes!). Shoppers purchase all kinds of items from handkerchiefs, to socks, ties. You name it.

Building costumes for the production involves establishing a shop and hiring supervisors and stitchers to make the costumes.

Most Broadway shows will utilize both approaches—pulling and building. A lot depends on the size and scope of the show, and of course, the budget. Sometimes building a show can be more cost effective than purchasing the costumes separately.

Costume Fittings

Costume fittings are always challenging for both designer and actor. Fittings have a fair sense of anticipation from the actor who has seen the renderings and visualized himself/herself in

the clothes from the moment they were first cast. During the fitting, the costume designer must gauge the actor's level of comfort, as well as develop the desired look. Good designers spend a great deal of time on the details of the costume—how the shoulders look, how the garment hangs, its length, cut, style.

Accessories

One aspect of costume design that is usually not noticed is the use of accessories. The effective use of subtle clothing details adds depth to characters without calling attention. They include: hats, jewelry, purses, earrings, gloves, scarves, etc.

As you watch plays, note how the costumer employs accessories to further define character and/or accentuate the actor's physique.

Lighting Design

Stage lighting, just like everyday lighting, exists to do more than just illuminate.

Huh? No one puts thought and planning into lighting, like they do clothes and wardrobe.

Or do they?

Of course, if you're on a date and you're coming back to your place for a romantic evening, I think the lighting will matter. If you own a store in a strip mall and you want to get attention, I think the lighting on your sign will matter. And finally, there's a reason why delicate chandeliers are located in the dining room and not the den.

The point is that the use of lighting on an everyday basis has a purpose that goes beyond just allowing us to see.

Well, the same is true for stage lighting. Illuminating the actors is only part of the goal; the other part is to establish the mood and the style.

Lighting design is one of the last design elements to be directly addressed with the director. This is because the designer needs to know who (the actor) and what (the set and the costumes) he is lighting.

Unlike the designer of sets and costumes, the Lighting Designer does not use renderings and drawings to illustrate his ideas, but rather a Lighting Plot. His Plot is a ground plan of the set that has little templates (representing various lighting instruments). He uses the plot to explain to the director how certain lighting ideas are achieved.

Effective lighting design accomplishes two basic objectives:

1. Visibility—audiences want to see the faces of the actors, which, of course, is essential. Good designers can achieve this even in darkly lit scenes that take place at night (I've always marveled at that).

2. Mood and style—The designer takes his clues from the text and works with the director's concept. Mood can be affected by several different lighting sources such as:

 ✓ Practical lights (actual sources of light utilized on stage) such as lamps, chandeliers, sconces, etc.

 ✓ the sun

 ✓ the moon

 ✓ other sources such as street lamps, neon signs, candlelight, etc.

Lighting design is heavily dependent on technology, and it seems new technological breakthroughs occur on a monthly basis. There have been recent innovative advances in both lighting instruments and in their programming. Sophisticated lighting devices, such as Vari-lights and moving lights, have given Broadway shows a rock concert look and feel. Computer programs can recreate stretches of time such as a long sunrise or the visual crack of split-second lightning.

Figure 11. Madame Butterfly
Lighting designed by F. Mitchell Dana. Observe how the lighting is incorporated with the scene design. The lights and sets are integrally connected to establish both interior and exterior.

The use of these refined instruments along with special computer programs allows a creative flexibility for designers to utilize all kinds of special effects. The average professional stage production features hundreds and hundreds of lighting cues—which is merely the timing of when the lights go on and when they go off.

What I Do...

"As a lighting designer I control what the audience looks at, and what they do or do not see. Along with the other designers in a highly collaborative format, I help to tell the story in a non-verbal, visual way discovering visual images of the text. I must remain highly sensitive to nuance and inferential reasoning.

We know, unless light is reflected from an object, we will see nothing. This is important, because the light one starts with, affect everything we see. I work from my visual imagination to determine where each light will be placed, what general quality it will be, how it will be colored, how it will be shaped, and how it will move.

I'm responsible for supplying the light that will reveal or add interest to all the scenery, and every costume. If I have done my job well, you will always know where to look, but never be aware of why you looked there. If I have done my job well, you will not notice it—you will follow the time line, understand the place and experience the emotions of the play."

F. Mitchell Dana
Lighting Designer

Good lighting design will also highlight these four aspects:

1. *Focus*. Where the light is aimed. It should "light" up the area where the actors are performing. A good design will avoid 'spill' so that the lighting for a particular area is contained. Larger budgeted shows will hire operator(s) to work a spot light for individual performer(s).

2. *Color*. Most lights are covered by gels which are thin plastic coverings that give color. Most lighting plots will have both warm (oranges) colors and cool (blues) colors.

3. *Shadow*. The absence of light is an under-valued aspect of lighting design but given the appropriate scene and context can be very dramatic and effective.

4. *Direction*. Where the light is coming from. Is the source a natural one, or "understood" (meaning that the audience understands there's no actual source but will accept the instruments above as the source)? Footlights can be strong illuminators putting a serious glow on the performers. Side lighting is used to highlight the features and contours of the body (very important for dance).

Figure 12. Royal Opera, London
Designed by F. Mitchell Dana, note the dramatic power of the lighting in establishing the mood, and how the light focuses your attention on where to look.

Sound Design

There are two basic kinds of sound design for the professional theater: sound reproduction and sound reinforcement.

Sound Reproduction is simply sound that is specifically addressed in the text, such as car honking, telephone ringing. Or reproduction can provide environmental ambiance, such as crickets in a camp fire scene or people talking in the background at a restaurant.

It's important that the recreations of these sounds are plausible and realistic. For example, if a director decides to use the audio system for a gunshot, hissing noise can be heard. A gunshot is obviously a powerful moment, and the hiss from a recording could alter its plausibility. Also the timing of the audio cue presents a challenge as well.

With ambiance sound it is important that it subtly remains in the background and does not overpower the scene. If the scene takes place outdoors, and the director wants to hear cricket sounds, the volume should be faint so that the experience of being outside is created without causing unnecessary attention to the sound cue.

Sound reinforcement is the amplification of voices and instruments. On Broadway, every performer and nearly all musicians are separately miked. This presents quite a challenge for the sound designer. But similarly to lighting design, advances in technology have allowed many changes. Wireless microphones, called lavalieres, are cleverly placed on the

performer. Sometimes these mics are located in eyeglasses or wigs. The popular musical *Rent* is well known for the use of headphone style microphones (Early in her career, pop music star Madonna made this style popular in her concerts).

Sound designers need to work closely with the costume designer to determine the most effective approach to plant the microphone and its corresponding transmitter in/on the costume. These microphones use lots and lots of batteries and need to be re-stocked on a regular basis.

A personal observation: the amplification of Broadway, particularly musicals, seems to be excessive. The theater seems to have taken on the attributes of sound design for a rock concert. In stadiums and concert halls, loud amplification of your favorite singer is necessary (if not to just be able to hear over the singing voices of the fans); there's less emphasis on the lyrics because fans in the audience already know the lyrics. But a musical is different; the lyrics are integral parts of the character and story. And as an audience member, you are usually hearing those words for the first time.

Being able to discern lyrics is an important component but all too frequently on Broadway that can be very difficult to achieve over screeching high decibels fostered by the loud sound systems.

The Producers

It's good to be the King.

—Mel Brooks

No, that quote is *not* from the smash Broadway hit, *The Producers,* nor the original 1968 movie of the same title, but rather Mr. Brooks' 1981 movie, *The History of the World, Part One* (don't think he ever made Part Two).

However, that phrase can best describe the producer of a theatrical production—the king. He serves as the ultimate authority, both financial and creative, for the show. He assumes the financial risk and burdens; therefore, he gets to call the shots.

Fire this person! Hire that person! Change this scene! The King.

The role of the producer has evolved over the years. Historically, producers were bold, charismatic individuals who possessed strong entrepreneurial spirits and shrewd business acumen. Due to economic shifts caused by the high costs of producing on Broadway, many producers today are a consortium of individual producers or employees for large corporations.

The Curse of the Bambino

It's 1920 and **you** are a Broadway producer who also happens to own the championship baseball franchise, the Boston Red Sox. The country is still reeling from the suffering caused by the Great War (World War I). The infamous Black Sox baseball gambling scandal of 1919 just occurred. And you haven't had a Broadway hit in a while and you're low on cash. What to do?

Sell George Herman Ruth (aka *The Babe* or *The Bambino*) to the Yankees. The Babe was the star pitcher for your championship baseball team.

As of 1918 the Boston Red Sox won their 5th World Series, including four out of the last six championships. This was the most championships won

> by any club at that time. On January 6, 1920, Red Sox owner Harry Frazee sold Babe Ruth's contract to the New York Yankees for $100,000.
>
> The selling of Ruth helped to finance Frazee's theatrical empire which eventually led to the hit production of *No No Nanette*. It has been well documented, since that infamous trade, the Yankees, who had never won a World Championship before acquiring Ruth, went on to win 26 world championships and the Red Sox subsequently lost the World Series four times (all in game seven).
>
> Of course, all the world knows what happened in 2004...the 86 year old "curse" was lifted and the Red Sox embarrassed the Yankees by performing the most miraculous comeback in American sports history and went on to win the World Series!

Whether from the old-style entrepreneurial model or a savvy employee of a corporation, a good producer must possess good leadership skills; he's a visionary who is inspirational and disciplined. He also needs to have a general working knowledge of theater and the various components necessary to produce a respectable production.

There are four qualities that well-seasoned producers possess:

1. Bold and daring

 It might be good to be the King, but it's lonely at the top. A good producer is a visionary. He sees what others cannot. Therefore a strong conviction is necessary along with the belief that it will be worth it in the end.

2. Financial acumen

 A critical component of producing is being able to understand budgeting, finance, accounting, and cash flow in order for the show to remain as a solvent functioning, business entity.

3. Leadership and wherewithal

 A producer is the ultimate salesman and he must get his supporters to believe in the show. This takes strong leadership where the producer understands the power of group dynamics along with the value of synergy (1 + 1 = 3, or the sum of the parts is greater than the whole).

4. Bat .300

 Seven out of ten Broadway shows fail to recoup their investment. With such a risky proposition, why then do producers still mount shows? Put the money in real estate—it's much safer! They do this because they have the conviction that their show will be in the percentage that succeeds. The belief is their show will be the next *Phantom of the Opera* and will run for 20 years.

Similarly, a successful baseball player is one who gets a base hit every three out of ten at-bats. He may have failed seven times, but batting .300 will get a player in the baseball Hall of Fame.

Broadway lore is full of charismatic producers. Each producer listed below represents a generation and their personalities are colorful and magnetic. Some have actually been the subject of source material as their life stories have been made into productions.

- ✓ **Florenz Ziegfeld** (1867–1932) was noted for his extravagant musical follies. He promoted musical attractions and later managed a number of famous entertainers, several of which became major celebrities, including the comedians Fanny Brice and W. C. Fields.

 In 1907, Ziegfeld introduced the follies revue that dazzled the American musical stage with beautiful chorus girls and extravagant sets. These highly successful revues became known as *The Ziegfeld Follies*. In addition, he also produced traditional musical shows, including *Show Boat* (1927), by Jerome Kern and Oscar Hammerstein II, and *Bitter Sweet* (1929), by Noel Coward.

- ✓ **David Geffen** (born in 1943) is an entertainment executive, record producer, and founder of Geffen Records, but he's also a Broadway theater producer. Early in his career, Geffen became a talent agent for musicians (singer Janis Joplin was a client). He became a millionaire at the age of 27. In the 1980s he went on to establish Geffen Records one of the leading record companies in the world.

 At that time he also entered the theater and motion-picture business. He co-produced the plays *Dreamgirls* (1981), *Cats* (1982), *M. Butterfly* (1988), and *Miss Saigon* (1991). In 1994 along with movie director Steven Spielberg, he co-founded the company DreamWorks SKG to create a major entertainment conglomerate. Geffen has also been a leading philanthropic supporter of research and treatment programs for AIDS.

- ✓ **Joseph Papp**, Producer, New York Shakespeare Festival, presented free performances of Shakespeare in New York famed Central Park. He also produced several commercial Broadway successes including *Hair* (1968) and *A Chorus Line* (1975) that originated in his Off Broadway Theater—The Public. Mr. Papp strongly believed that the government should support theater in the same way that libraries are supported.

- ✓ **Harold Prince**, who has won more Tony Awards than anyone, is a distinguished director and producer whose career has spanned five decades. His Broadway career began in the 1950s as a stage manager. He then went on to produce a canon of classical musicals—*The Pajama Game, Damn Yankees, West Side Story, Fiorello!, A Funny Thing Happened on the Way to the Forum,* and *Fiddler on the Roof.* In the late 60s he began directing shows as well, including *Cabaret,* and *Zorba.* His directing continued as he developed an enduring partnership with composer Stephen Sondheim, as they dramatically reshaped the presentation of the modern musical with such works as *Company, Follies, A Little Night Music, Pacific Overtures,* and *Sweeney Todd.* He also directed the works of Andrew Lloyd Webber with *Evita* and *The Phantom of the Opera.*

- ✓ **Lucille Lortel** was one of the first major female theater producers. In the 1950s and 60's she was a leader in the burgeoning Off-Broadway movement. An enigmatic

woman with fine-tuned taste for the off-beat, Lortel produced some of the most fearless and innovative pieces of theater in New York. She has a theater named after her, as well as prestigious Off-Broadway awards.

✓ **Margo Lion** received a Tony Award as the lead producer of *Hairspray*. She has produced Tony Kuschner's *Angels In America* and *Jelly's Last Jam* on Broadway. Her productions have garnered 11 Tony Awards, 19 Drama Desk Awards, six Obie Awards and one Pulitzer Prize. She is a dynamic force in today's commercial theater yet still maintains her independent status in a male-dominated environment.

Now you have a sense of the qualities needed to be a producer and examined a few profiles of dynamic producing personalities; basically, a confident producer possesses a general working knowledge and understanding of the major elements of mounting a show.

The mounting of a professional theatrical production is a labor intensive, exhaustive and sophisticated process. It involves the convergence of several forces:

✓ Creative (playwright, director, choreographer, designers)

✓ Production (stage management, rehearsal management)

✓ Technical (scenic and costume construction, lighting rental, special effects)

✓ Administrative (contracts, legal, insurance, negotiations)

✓ Union relations (actors, stage hands, musicians, etc.)

✓ Finance (payroll, vendor management, investor relations, accounting)

✓ Marketing (advertising and press relations)

That's Taboo!

Nathan Lane garnered rave reviews for his role as an unscrupulous Broadway producer Max Bialystock in Mel Brooks' popular musical *The Producers*. Producers have a general rule that harkens back to glory the days of Broadway—never put your own money in a show. That's what investors are for.

During the 2003 season, Rosie O'Donnell produced a new Broadway musical called *TABOO*, which starred Boy George, featured vocalist of the 80's pop music group Culture Club. Ms. O'Donnell is on record as saying she invested her own money in *Taboo*, supposedly some $12 million dollars. *Taboo* closed after only three months and 100 performances.

There's a line in *The Producers* where Mr. Lane character states that one should never put your own money in a show. Clever actor that Mr. Lane is, he added to the end of that statement "that's TABOO!"

And that's just the tip of the iceberg! If the producer doesn't have a handle on these aspects, well, he and his production could be wasting a lot of money. How much? Well, if you're talking about producing in NYC, potentially several million dollars.

Artistic Directors as Producers

In the world of Regional Theater (professional theater companies located outside of New York City, most of which are not-for-profit organizations), the producer basically goes by the title of Artistic Director. In this role, he/she works for a not-for-profit organization which normally has limited financial resources and the theater's organizational goals are more artistic rather than financial.

An Artistic Director is charged with upholding the mission of the theater. Most theaters of this type usually employ a Managing Director who handles most of the theater's business matters, like budgets, contracts, etc. We'll discuss this kind of operation shortly.

Corporations on Broadway

High schools and community organizations all across America produce several classic musicals on a regular basis. Take *West Side Story,* first produced on Broadway in 1957 at the capitalization cost of $300,000. A Broadway revival of that show is now in development and it will cost probably $10 million dollars to mount. The local YMCA producing *West Side Story* might cost a couple thousand dollars.

You don't need to know calculus to compute that if an individual producer has one show fail on Broadway, he's ruined! Finished! So in pure Darwinian practice, corporations have discovered the Broadway stage. Stepping back and putting personal issues aside, given the current economies of scale and how union labor is positioned, corporate involvement on Broadway was inevitable.

These corporations hire seasoned theater managers to serve as producers who are employees of the company. As an employee, the producer serves as an agent of the corporation and the main purpose is to protect the interest of the company. A corporate producer also has a lot more resources at his disposal than an independent producer. A full marketing staff, press and public relations staff, finance, legal, etc. are all corporate co-workers. Oftentimes, these other personnel are juggling several other projects and some might not possess specific expertise in theater.

Probably the single most important resource a corporation producing on Broadway has is deep pockets! Cash, dinero! Dough-ray-me! Moolah! Not having to constantly raise capital allows the producer to concentrate on other items such as corporate bureaucracy, perhaps.

Corporations also establish sophisticated and multimillion dollar marketing campaigns. The result of which sometimes end up marginalizing the impact of critical newspaper and media reviews. Walt Disney Theatricals' production of *AIDA* is a case in point. When it first opened, the reviews for the show were not that flattering, although it's star and future R&B

recording artist garnered a Tony Award for her performance. It is doubtful that an individual producer would've had the resources to be able to keep the show running after such tepid notices. But the Disney marketing experts put together a plan and the show ran for five years and a total of 1,852 performances!

Corporations on Broadway

Disney Theatricals: *Beauty and the Beast, The Lion King, Aida*

Clear Channel: *The Producers, Movin' Out, Spamalot*

Cablevision/Radio City Entertainment: *A Christmas Carol, The Scarlet Pimpernel*

Corporations with newly established Theatrical Divisions—coming soon to a Broadway Theater near you:

Dreamworks SKG. In development: *Shrek, The Musical!*

Columbia Pictures. In development: *Spiderman, The Musical!* (Julie Taymor, director of *The Lion King,* has been rumored to direct)

Part III

The View Outside

 # The Genres

In 2000, *Contact,* directed by Susan Stroman, won the Tony Award for Best Broadway Musical. However, this production did not have a live orchestra and not one person in the cast sang a song. Actually, no one in the cast really spoke much either. What did they do? They danced.

The show was presented as "a dance play" as it consisted of three short dance vignettes with recorded music. One news publication described the show as "a dream ensemble of dancing actors and acting dancers." Was it a dance show? Or a play?

I gather that since it was produced by Lincoln Center Theater Company and all of the creative folks involved work professionally in the theater, it was viewed as a theater work—a play. But what if renowned dance company Martha Graham produced the show?

Would it still have been considered for a Tony? Would it have even played on Broadway?

Well, in 2002, respected dance choreographer Twyla Tharp took the songs of Billie Joel, added a thin little plot and choreographed herself a Broadway musical. Subsequently, *Movin' Out* was nominated for several Tony Awards including Best Musical. However, *NY Times* dance critic declared:

> "I am perfectly willing to call *Movin' Out* a show, and a terrific one at that. What the production is not is a musical, newfangled or otherwise, just because it is produced on Broadway. There is no dialogue, the dancers don't sing and the lyrics are sometimes irrelevant to the dancing."

A genre is a particular category of artistic composition marked by a distinctive style, form, or content—a classification of the story. What is becoming exceedingly more and more difficult is to do just that—classify. It is difficult, and aesthetically dangerous, to classify plays because it leads to pigeonholing, which can ultimately be constricting to the inspired artist.

As observed in the Playwright chapter, **conflict** is central to all dramatic stories. When examining a play's genre, it is important to note the STYLE in which the conflict is executed. Is it humorous, realistic, naturalistic, or melodramatic?

Artists challenge themselves to elongate their creative boundaries by discovering new and exciting approaches to communicate their stories. As an audience member, this is thrilling to witness.

Move Out—Make Room for Hairspray

Just for the record, after *Contact* won Best Musical, the Tony Awards then established a special "Theatrical Event" category, this means that traditional plays and musicals don't have to compete with special, hard-to-define events. Prior winners in the Special Theatrical Event category include: *Blast!*, a show with a huge compliment of drummers, and the hip-hop poetry slam, *Russell Simmons' Def Poetry Jam*.

However, in spite of the *Times*' protests and insistence that it was not a traditional musical, Twyla Tharp's *Movin' Out* was indeed nominated in the Best Musical category; however, it lost to *Hairspray*.

Even though categorizing works into genres can be constricting, in a general sense it can be helpful because the framing of the work generally induces further analysis by those who observe the work. This subsequently creates comparisons of various different works and different artists. Furthermore, these examinations can be even more intriguing when different eras of work are studied and compared.

For example, at one point in our country's history, Minstrel Shows (performers dressing in 'black face' and mimicking slaves) were extremely popular entertainment. Produce a Minstrel Show now and there definitely would be a sizeable and vocal public outcry.

As we progress as a society, defining theatrical works becomes more challenging. There have been instances where an audience is laughing throughout the entire evening of a play, but the show was presented in a serious fashion and seemed dramatic. These contradictions point to the sophistication of audiences and how artists enjoy pushing the envelope (See Neil LaBute's comic tragedy *Fat Pig*).

This chapter is not designed to be an exercise in Theater History but rather to review a few general classifications to assist in assessing how to frame certain plays. Throughout history various regions around the world have put forth their own particular genres and styles of theater.

Below is a general overview of various compositions of artistic work as we examine comedies, dramas, and musicals.

Comedy

Why is something funny? And more to the point—what makes us laugh? Most comic moments possess at least one of the following three elements:

1. Unexpectedness

2. Incongruity

3. Exaggeration

There are also psychological elements at play that cause laughter. Think of a clichéd funny situation—a man slips and falls. This is unexpected. What if he was a large, obese man—it might be funnier (exaggeration)? Then add that he speaks with an upper class British accent and then slips and falls (incongruity). On this simple level, note the elements of comedy at work.

A theater production that is labeled as a comedy when the play is of a happy nature that's light in spirit with amusing dialogue and an uplifting ending. At times, it's tempting to classify dramatic works as comedies because oftentimes they possess funny characters, scenes and/or situations. But the *fundamental composition* of the work needs to be examined. Ask yourself—is the script essentially designed to cause laughter?

Comedy is one of the oldest enduring categories of Western drama. Like all genres, comedies have evolved over the years. Don't believe me? Just watch any cable channel showing television re-runs from past decades and it's hard to believe that a particular joke or situation was considered humorous at that time.

There are several different kinds of comic styles, all designed to make us laugh.

✓ *Slapstick*—physical comedy that's often abusive and violent. Style was prevalent in older cartoons (Bugs Bunny, Popeye).

✓ *Sketch comedy*—short skit that's complete in and of itself (vignette), usually presented within a larger framework. (NBC's *Saturday Night Live* is a leading example).

✓ *Farce*—wildly improbable action; usually designed to illustrate a point-of-view.

✓ *Satire*—comedy that uses wit, irony and exaggeration, usually to illustrate a point. Editorial cartoons in newspapers are good examples of satire.

✓ *Comedy of Manners*—satirizes high society. Works of Noel Coward.

Recently, Broadway has seen several stand-up comedians performing their routines for an entire evening. Some examples:

Dame Edna	*Back With A Vengeance*
Jackie Mason	*Freshly Squeezed*
Billy Crystal	*700 Sundays* (2005 Tony Award—"Best Theatrical Event")
Whoopi Goldberg	*Whoopi*

There are numerous great comic plays, a few examples of my favorites are:

A Comedy of Errors by William Shakespeare

White Liars/Black Comedy by Peter Shaffer

You Can't Take It With You by George Kaufman and Moss Hart

Noises Off by Michael Frayn

The Odd Couple by Neil Simon

Sister Mary Ignatius by Christopher Durang

Bedroom Farce by Alan Ackybourn

Drama

This genre covers the majority of the inventory of plays. A drama is simply a representation of real life, which is generally serious. Dramas are serious plays but not to be confused with tragedies. Serious drama requires a thoughtful audience—members who are willing to take an analytical and sometimes sobering intellectual perspective on a challenging and emotional subject matter. Theater, because the performers are in front of you—live and immediate—can sometimes heighten the dramatic experience more than film and television.

Briefly looking at the drama genre, here are a few sub-categories:

✓ *Realistic Drama.* Representation of everyday life through careful attention to detail. Good example: Tennessee Williams' *Streetcar Named Desire*.

✓ *Tragedy.* Serious drama with an unhappy ending usually ending in death. Shakespeare's *Othello, Hamlet, MacBeth*.

✓ *Documentary Drama.* Based on factual events. Popular play, *The Laramie Project* about the vindictive murder of a gay man, Matthew Shepard.

✓ *Domestic Drama.* Problems of the modern family—husbands and wives, children, etc. *The Goat or Who Is Sylvia?* by Edward Albee.

✓ *Poor Theater.* Theater stripped to its bare essentials. No lavish set, lights or costumes. Audience relationship to the actor is what matters most. Popularized by Polish director Jerzy Grotowski.

✓ *Tragi-comedy.* Stories where comic characters or situations have tragic outcomes. *Waiting For Godot* by Samuel Beckett.

✓ *Melodrama.* Confrontation between good and evil with shallow characterizations and stereotypes. Good usually triumphs.

Musicals

> In the classic Stevie Wonder song, *Sir Duke*, music is defined as having a language that is understood by everyone.

The vast majority of the shows on Broadway are musicals concluding that it is certainly the most popular genre of theater. The Broadway musical owes its heritage to Opera, a form in which all dialogue is sung to orchestral musical accompaniment. But the modern musical is largely of American origin, which first began with *musical comedies*.

It's also interesting to note that Musicals can also be presented in different sub-genres—comedies, satires, dramas, fantasies, and tragedies.

Perhaps a reason why musicals are so popular is the idea of *fusion*, which is a cohesive blending of drama, music and dance. Both music and dance are such an integral part of our society. Music permeates our daily life—radio, music videos, walkmans, I-pods, background music (elevators, dentist office, etc.); even the evening news now has a musical underscore. Dance still defines our sense of romance—proms, weddings, and nightclubs. Couple these elements with a good story, and you have enthralling components upon which to tell a story. And, ta-DAH!! You've got yourself a musical!

Crafting a musical is one of the most daunting and intimidating creative efforts in the theater. Several writers are usually needed to create the work; there are usually two to three people sharing the duties of the composer, the book writer and the lyricist. There are three main components of a musical: the book, the music and the choreography (dancing).

Book

In theater terms, the book of a musical is simply the plot. It's also called the Libretto, which is Italian for "little book." Frequently the composer of a musical receives the lion share of attention but the contribution of the book writer is often an undervalued aspect. The book serves as the skeleton of the musical because it literally supports and holds the evening together. No matter how great the music is, if the story isn't revealed in a compelling and interesting way, then the show is in trouble.

Source material for new musicals is very challenging to find. Usually the most obscure concepts make for appealing musicals:

✓ A barber seeking revenge slaughters victims who end up as the main ingredient for the tastiest meat pies in London—*Sweeney Todd*

✓ Due to an extensive drought, private bathrooms are outlawed and the townspeople have to pay hefty fees to use public latrines—*Urinetown*

✓ A sensational murder trial is acted out in vaudeville style specialties—*Chicago*

Therefore, the book writer must possess the skills and attributes discussed earlier in the Playwright chapter such as effective use of set-up, conflict, and resolution. Furthermore, the story must be embodied with characters that also resonate, engage and fascinate.

Music

Naturally, the key element to a musical is the music. If the book is the skeleton, holding up the show, then the music is the **heart** and **soul**. Well-crafted music provides an energy that transcends beyond the notes on the page; it synthesizes the story, the characters and the other elements of the production to formulate the spirit of the work.

The composer is the creator of the songs and music. Most composers will develop the melodies for their songs at the piano. (Orchestrations, musical parts for the other instruments, are later added). When developing songs for a musical, the composer has three basic objectives for the songs:

1. Relating to the story overall

2. From the character's point-of-view

3. Should advance the story and/or further define character

The best songs are simplistic and active while capturing the essence of the moment; some examples are:

✓ "Something's Coming" by Leonard Bernstein and Stephen Sondhiem, *West Side Story*

✓ "Just Can't Wait To Be King" by Elton John & Tim Rice, *The Lion King*

✓ "Tomorrow" by Charles Strause, *Annie*

✓ "God I Hope I Get It" by Marvin Hamlisch and Edward Kleban, *A Chorus Line*

Even if you are unfamiliar with the songs listed above, it's relatively easy to develop some sense of what they're about simply from the title.

Lyrics

Lyrics are the words set to the music. Frequently Broadway composers are comprised of teams where one partner writes the music and the other partner, the lyrics.

Writing lyrics for a show is not quite the same as writing lyrics to a popular song. The words sung in a musical must be from the point-of-view of the character and the lyrics need to be both imaginative and literal. And finally, the lyrics must fit into the overall vision and structure of the musical.

Schoolhouse Rocks

If your parents grew up in the 1970's and watched Saturday morning cartoons, they are certainly aware of *Schoolhouse Rock,* an innovative teaching tool where short educational songs were presented. It was pleasing to discover that the current generation of kids is aware of *Schoolhouse Rock* through video distribution.

One of Broadway's treasured lyricists, Lynn Ahrens (*Ragtime, Suessical, Dessa Rose, Once On This Island*), composed several *Schoolhouse Rock* tunes during her college days.

The lyrics of those songs epitomized song-writing craftsmanship by capturing the song's true meaning, which was ultimately educational yet it was fun.

✓ "Interjection!"

Witty tune that suggests the part of speech that is also an expression—Rats!!

✓ "Conjunction Junction"

This tune conveys how conjunctions work grammatically and cleverly used a metaphor with a railroad station.

✓ "I'm Just A Bill"

This song focused on the lonely, political life of a Bill stuck in committee in Congress waiting to become a law. The song presents an introductory view of law creation on a Federal level.

There are lots of elements to the music—two in particular are instrumental and vocal.

Instrumentally speaking, the size and composition of the orchestra or band plays a vital role in the musical. The size, sound, feel, and mood of the music all should relate to the story, in general, and the scene in particular.

Vocally speaking, the quality of the performer's voice should blend with the other actors. The voice must be within the appropriate vocal range.

Choreography

The choreography of a show is simply the arrangement of bodies in motion. Dancing in a musical must take into account so many different elements—story, character, music, moment, and the other performers. Well-crafted choreography should enhance all of the elements above. The dance should flow to present the unified ingredients to tell the story in an engaging fashion.

> ### Play/Concert/Dance = Musical
>
> One of the reasons I enjoy a musical so much is that it's a profound approach to tell a story (Although I'm not that big a fan of musical comedy). A dramatic story being told through music and dance.
>
> Audiences support dance companies. Audiences go to symphonies and music concerts—both classical and pop. Fuse both of those elements together and you have the ingredients for a captivating evening of entertainment.

Other Noteworthy Genres

Revue. A musical without a book usually has a unifying theme. *Smokey Joe's Café.*

Ensemble. Cast works together as a team; all members are, or have, equal parts.

Reader's Theater. Actors read from book, sometimes remaining in third person.

As I write this and you read this, somewhere a playwright or director or choreographer is typing away at their laptop or writing in their notebook to create a new innovative approach to present a play which will once again push the established boundaries of genres.

The Commercial Theater and the LORT

Another word for the commercial theater is Broadway.

And Broadway productions are separate from other productions throughout the country because their major goal is to "sit down" (stay in a specific theater for an extended amount of time, an open run). However, Broadway is getting competition in other regions of the country—most notably Las Vegas and Anaheim, CA.

OK, you can figure about Vegas, but Anaheim? Yes, Anaheim, the home of Disney Land where you can see full musical versions of *Aladdin* and *Snow White*. And several theaters are under construction in Las Vegas with the hope and promise of Broadway shows (*Avenue Q* is scheduled to open a sit-down production in Vegas).

But for all intents and purposes, the main focus of commercial theater in the US is on that long, diagonal street in New York City that used to be a cow path known as Broadway—the symbol of live professional theater that's known throughout the world.

New York's Theater District stretches from West 41st Street (home of the Nederlander Theater which is occupied by *Rent*) up to West 53rd Street, location of the Broadway Theater. The district is flanked to the east and west by Eighth Avenue (well, there's one theater that's located to the west of 8th Avenue—the Hirschfeld Theater, recently renamed in honor of Broadway line artist Al Hirschfeld). The side to the east is Sixth Avenue (which also houses Radio City Music Hall; due to the enormity of its size—capacity of 6,000—it's not considered a Broadway house).

Those streets form a rectangle and there is one street that dissects that rectangle diagonally: Broadway.

Although there are 43 theaters located in the district, only three are actually physically located on Broadway (the Marquis at 46th Street, the Winter Garden at 50th Street, and the aforementioned Broadway at 53rd Street). The seating capacity for most of these theaters

ranges from 700 to 1,800. Most shows appearing on Broadway are musicals as they are designed for mass appeal and can generate millions of dollars in revenue. Straight plays are generally produced either Off Broadway or in regional theaters.

Times Square—The Clock on New Year's Eve?

People often wonder how Times Square got its name. Most incorrectly conclude because the New Year's Eve ball drops there every year, therefore it's called "times" square. Good guess.

It's called that because of the location of the New York Times building, 43rd Street.

(Get it—Times Square.)

Times Square is in the heart of the Theater District. Superior acting, intricate and dazzling scenic design, and works of popular appeal characterize Broadway shows.

The standards of Broadway are high because historically the word "Broadway," in the theater vernacular, defined only venues that allowed union workers. Thus, salaries for Broadway professionals, writers, directors, designers, and actors, were, and continue to be, the highest in the nation. Being a success on Broadway can help define an artist's career, as well as his bank account.

Most shows that open on Broadway have one objective: to have legs.

What the heck does that mean? Legs!? That's show biz lingo—to have legs means to run. When the show opens, the goal is to run and run—seemingly last forever, like *Cats*, and *Phantom of the Opera*, and *The Lion King*. That's why producers continue to produce plays; even though more-than-likely they will fail but they believe their production will be a big hit, which will subsequently earn millions!

As we discussed in the Producer chapter, the costs of producing on Broadway are staggering, which then necessitates a high ticket price, which in turn alienates several potential audience segments who are priced out of attending. One-hundred bucks for a show is a lot of money to most Americans.

Most shows are available and not "sold out." In the final chapter, we will review several options to get quality seats at low prices (as much as 50% off!).

Growth of Resident Theaters—LORT

As a result of high economic stake, a shift occurred in how and where shows are produced. They're called resident theaters and they operate under the collective representation of LORT, or the League of Resident Theaters.

Approximately 75 theaters operate under LORT and the level of production quality is quite high. In fact, on a few occasions, these theaters produce shows that actually "transfer" to Broadway. A recent example of a transfer is Pulitzer Prize winning play, *Anna In The Tropics*, which originated at the McCarter Theater in Princeton, New Jersey.

The criteria to be a member theater of LORT are as follows:

- ✓ Theater incorporated as a non-profit I.R.S. approved organization
- ✓ Each production must be rehearsed for a minimum of three weeks.
- ✓ Theater must have a season of plays consisting of 12 weeks or more.
- ✓ The theater operates under a LORT-Equity Union contract.

How does the goal(s) of LORT differ from Broadway?

LORT organizations are tax-exempt and fall under Section 501(c)(3) of the IRS Code, which states they are organized for an educational purpose that ultimately will serve the public. So a regional theater, like the Papermill Playhouse in Millburn, N.J., or the Alliance Theater Company in Atlanta, GA, produces theater for the sole purpose of educating the public. Profit and commercialism are not their objectives.

People constantly say what a not-for-profit organization isn't, but it's harder to define what it is. It's an organization that has a mission to serve the public and the mission has to be educational or charitable. The IRS allows resident theaters a classification similar to museums, where the artistic works are considered valuable educational experiences.

For theater, classic plays such as those by Shakespeare or Eugene O'Neill can be revived and new classics, such as *Anna In The Tropics*, can be written. Non-profits cannot financially benefit any one individual (this does not preclude reasonable compensation) nor can they actively engage in political activism.

The IRS also allows for a unique aspect of financing for not-for-profits—charitable giving. So as a taxpayer, you donate money to a LORT company and receive a tax deduction. Also, the non-profit does not have to pay taxes, not income taxes, not property taxes, and not sales taxes. This serves a huge benefit for social organizations, but also realize that the government is off the hook. Theoretically, if the non-profits did not exist, a lot of the services provided by these organizations would then have to be provided by the US government. Even though these theaters enjoy tax advantages, additional fundraising support is necessary because ticket prices only cover about half the cost of producing a show.

The quality and growth of non-profits over the years has been impressive. Major regional theaters, in Washington DC, Seattle, San Diego, Louisville, Orlando, Minneapolis, and San Francisco, are model representations. Furthermore, these organizations have been embraced by their communities as some have new facilities recently constructed. On a few occasions, high caliber and talented artists are eager for work opportunities at some of these organizations.

Check out your local paper and visit your local resident theater. And if you really like what you see, take out your checkbook (or have your parents write the check) and send a donation.

Not-for-Profits on Broadway

LORT theaters can enjoy lots of benefits when one of their shows 'transfers' to Broadway. There are financial rewards that the IRS will allow if basically the organization is not financing a major portion of the transfer but rather are merely passive participants. However, the prestige from producing on Broadway can greatly enhance fundraising efforts in the theater's community.

In the 1970s Joseph Papp's Public Theater forged an enviable model with the smash production of *A Chorus Line*, which originally played in the small Public Theater space downtown on Lafayette Street. After the show transferred to Broadway, it was a success and ran for 15 years. The income received from *A Chorus Line* enabled Mr. Papp to finance several other productions over the years.

The Sales

F.I.T.S

That's the name of the game in show business. You want FITS. What is FITS you might ask?

Fannies in the seats.

Whether you're under the marquee on Broadway and 46th or on Main Street at Aunt Polly's School of Drama, a sold-out house is an exhilarating experience for the performers and the producers.

It's impossible to proceed in American society without being bombarded to purchase something. Commercials, pop-up ads, phone solicitation, billboards, the list goes on and on.

As a source for entertainment, the popularity of theater lags sorely behind television and movies. Therefore, marketing theater is extremely overwhelming, and just downright nearly impossible to achieve without spending huge amounts of dollars on advertising. This is basically true in New York as well as the regional theaters through out the country.

Nowadays, perhaps more than ever before, living our lives is very complex and it seems the demands on our time have never been this high. (This seems quite paradoxical when you consider all the technological innovations that were made to make our lives simpler and easier.) Nonetheless, getting majorities of folks to purchase tickets to plays remains quite a challenge.

Marketing a professional show involves the systematic process of viewing the show from the audience's point-of-view. This presents a challenge because, in business terms, a theatrical production is both a good and service. This is because the actual "product" purchased is merely a thin strip of cardboard (the ticket), and the "service" is a two-and-a-half hour experience, an entertainment encounter (one that is hopefully positive).

The most effective marketing campaigns for theater productions, or most entertainment events for that matter, focus on the "experience" that the audience realized at the show.

There are two basic ways a producer can market to the general public: advertising (and that one cost money) and public relations (and this one is free).

Advertising

For promotional purposes, most shows purchase advertising space and/or airtime to communicate the production to potential audiences. Advertising, particularly in New York City, is very expensive, plus the marketplace is very crowded. Trying to penetrate through the myriad of ads already flooding newspapers, airwaves, the Internet, and radio is very demanding.

For most professional theaters in New York, exposure in the *NY Times* is vital as a major portion of the theater-going public are readers of the paper. On average, a full page color advertisement in the Sunday Arts & Leisure section can cost as much as $75,000. Here's a brief look at a few other advertising options for professional theaters in NY:

✓ TV commercials—this approach can be very effective but also very costly. Production of a television spot is expensive because showing scenes from the show is necessary and union regulations stipulate lots of workers on the show have to get compensated. Then add costs of the crew to film the spot as well as various union session fees, you can see that production of a commercial could easily cost $100,000.

 Then a producer still has to purchase the television airtime. This, too, has become more sophisticated, as the market is very fragmented with so many niche channels. A producer has to select the broadcast times and frequency wisely.

✓ Radio—depending on the show, radio can be an effective method to advertise a show. The written copy can be changed quickly to reflect show changes such as the recent publishing of a rave review or announcing a new cast member. Several recent surveys illustrated that theater goers primarily listen to lite music stations as well as classical and jazz music stations. Radio interviews with cast members and on-air ticket giveaways are always welcome.

✓ Direct mail. Identifying interested and motivated residences can be effective. On the other hand, so much clutter comes via the mail; the motivated audience member might not ever notice the mail-piece.

✓ E-marketing. This method has soared in popularity recently. It's relatively inexpensive and is appealing to a very targeted niche. In NYC there's a plethora of web sites especially designed for theater fans. TheaterMania and Playbill have popular electronic marketing programs, as does the *NY Times*.

✓ Billboards. They are expensive but can be an effective way to reinforce previous impressions.

✓ Telemarketing. Some producers still believe in this approach. It can be costly and time-consuming. As a society, values have shifted so now sales calls are looked upon as intruders.

✓ Posters. Hey, it worked for Shakespeare! The heart and soul of grass-roots marketing.

> ### Female Ticket Buyers
>
> According to the League of Theater Producers, 63% of the Broadway audience is female, and they also represent the primary decision-makers in show selection. One of the most effective methods to reach these women is morning television talk shows.
>
> Watch the NY affiliate broadcast of the *Today Show* on NBC or *Good Morning, America* on ABC and you can't help but notice a sizeable number of commercials for Broadway shows.

Branding

Perhaps the ubiquitous swoosh popularized by athletic shoe company, Nike, is the best example of the power of branding, where the lone image of the company's logo dutifully informs the public about the quality and essentials of the company's products.

It's interesting to note that some Broadway producers (well, mostly British producer Cameron McIntosh and the guys at Disney) recognized the marketing opportunities of "branding" a show.

Show	Image/Logo	Producer
Aida	pyramid with eye	Disney Theatricals
Beauty and the Beast	beast with rose	Disney Theatricals
Cats	eyes of a feline	Cameron McIntosh
Les Miserable	baby picture in flag	Cameron McIntosh
Lion King	face of Lion	Disney Theatricals
Miss Saigon	moon with helicopter	Cameron McIntosh
Phantom of the Opera	white mask	Cameron McIntosh

Press/Public Relations

Any effective advertising campaign must be complimented with a coherent PR strategy, which entails placement of information about your production in various media outlets (newspapers, television, web sites, and radio).

In order to receive placement in a competitive media marketplace, a show must establish itself as being newsworthy. In other words, the production must be of interest to others because the media sources want people's eyeballs to read and/or watch their publications.

Positioning the production as a compelling property and initiating the show as a unique and special event do this. This could be accomplished in numerous ways by examining the show's:

✓ Subject matter

✓ Cast members

✓ Author

✓ History

✓ Theater

On Broadway and in most regional theaters, a press agent is hired to specifically work with the media to insure proper coverage. A good PR campaign includes feature articles as well as insuring that the production will be critically reviewed. The press agent will utilize his/her contacts and/or industry experience to generate "buzz" about your show. Buzz is created through:

✓ *Press releases*. Pre-written stories sent to Editor's desks of publications and networks.

✓ *Featured articles*. Detailed preview stories about the production, presented via a particular angle.

✓ *Gossip columnists*. The Liz Smith, Cindy Adams, and Page Six columns. Excellent opportunities to create excitement about a show. It's exceedingly hard for theater to receive placement here unless celebrities are involved in the show.

✓ *TV appearances*. Excellent source but hard to book. Morning talk shows provide excellent PR opportunities. Late night talk show appearances are helpful as well.

✓ *Radio*. Can be effective if the demographics of the station match the show's audience. Interviews and ticket give-aways can be a good marketing source. Watch out for whacky morning drive DJs noted for shock-jock style. They've been known to ask actors all kinds of questions including ones about their personal life.

✓ *Special events*. Can help to generate awareness. A good example is the Radio City Rockette's *Christmas In August*. Sixth Avenue is shut down at lunchtime, the long-legged Rockettes dance in the street, the mayor is dancing with Santa and it's snowing (well, it's actually confetti). Great photo op for a hot summer day.

Comin' Up Rosie!

When her morning talk show was still on-the-air, Rosie O'Donnell was the best friend to many a Broadway press agent. She's an avid theater goer who constantly went to Broadway plays and would discuss the play the next day on her show. She would frequently invite performers to appear on her show. This kind of publicity was enormously influential and was certainly appreciated by the Broadway community. Her valued support and enthusiasm are certainly missed.

This brief overview of the marketing efforts necessary to produce a Broadway show is designed to highlight the tremendous effort and coordination that's necessary to have FITS.

 # The Critics

I used to say, "Nobody grows up wanting to be a critic."

That was until I started teaching on the collegiate level and have since mentored many students who aspire to become critics.

I suppose if I were to ask these college kids if they wanted to be a critic at nine-years-old, the presumable answer would be "no." For obvious reasons, most of us in the profession initially want to act on stage (yikes!). And then for various reasons, we found our callings in other capacities (thank goodness!).

In a sense, though, we are all critics, even though we're not employed as such and are not on a news publication's payroll.

Go to see the newest motion picture release over the weekend ... then go to work on Monday ... does this conversation with a co-worker sound familiar?

Pierre: What'cha do over the weekend?

Jean: Went to the movies.

Pause button. OK, I guarantee you 99% of the time; the same two questions will follow as this happens every Monday at water coolers and in elevators all across the country.

Pierre: What'cha see? (**Question #1**)

Jean: Oh, such-and-such <insert movie here> starring such-and-such <insert favorite movie star here>

Pierre: How was it? (**Question #2**)

There you have it ... Jean from Queens is now a seasoned, scholarly critic who offers her opinion about the movie. But, hey, we all do it.

I really marvel at the 'collective power' of the true critics—the general audience. It's fun to observe the marketing surrounding movie grosses as Hollywood executives position a movie's marketing strategy based on its opening weekend box office sales. They play all kinds of games with wording too. But what should always be observed is the sales from the second weekend.

That's the most impactful because all the Jeans-from-Queens in the country have offered their uniquely qualified opinion and what becomes the main marketing operative is not a slick multi-million dollar campaign but rather good old fashioned word-of-mouth—which we all know is the best and most effective marketing tool.

One Week Wonders

The most effective approach to gauge a movie's popularity and success is to examine the second week of sales. A movie with real popular appeal should have sales as strong or surpass the first week. According to MovieWeb.com, as of the first four months of 2005 only one movie has successfully maintained the top sales spot for two consecutive weeks...

| HITCH | February 11th | $43,142,000 |
| HITCH | February 18th | $31,356,000 |

One week wonders in the first quarter of 2005* include such masterpieces as:

Robots	The Ring Two
Guess Who	The Amityville Horror
The Hitchhiker's Guide To The Galaxy	

The public has spoken!

This proposition exists in the professional theater world as well, although not as frequent. The critics primarily dismissed the Broadway musical based on the song catalog of the singing group Abba, *Momma Mia*. However, the show is enjoying enormous success on a worldwide basis.

But I digress ... historically the critic has a love-hate relationship with theater productions. The critics can both be friend and foe ... but they are certainly necessary. When they rave about a production, the producer immediately puts the critic's words in advertisements and on the marquee (complete with obligatory exclamation point):

"Fabulous!"—*New York Chronicle*

Legend has it that this has been done even when the critic's only positive comment was about the "fabulous costumes."

Like our friend Jean at the water cooler, a critic is a responder to the theatrical work. The main difference between the critic and the public is that the critic possesses higher standards. He/she challenges the artistic to create and function at a superior level. The critic's review then becomes a mouthpiece to the public—an intellectual capsule of the positive and negative components of the play where hopefully, the reader (or watcher or listener) can be the ultimate judge.

Reviews of plays seemingly have more influence over the public than reviews of movies. Economics play a major role in this. As discussed earlier, attending theater is an event, not a spur-of-the-moment excursion. The investment in a movie is approximately ten dollars, and of course, a Broadway play is ten times that amount. So strictly observing this situation in economic terms, one can more readily accept getting "misleading advice" about a movie more so than a play.

Therefore, theater critics in the professional theater scene in NY wield a lot of power. However, because of sophisticated marketing techniques as well as the emergence of the Internet (complete with dozens of theater websites offering discounts and gossip and theater news), the influence of critics has waned recently along with the reliance and dependency of reviews. But reviews still play a major role in the overall marketing of a production.

Reviewers on the WWW

In addition to longstanding publications (i.e. *NY Times, Wall Street Journal,* etc.), below is a list of web sites offering reviews of Broadway shows (and there's even more that covers Off Broadway and Off Off Broadway).

nytheatre.com	backstage.com
theatre.com	nytheatre-wire.com
ny.com/theater	playbill.com (descriptions)
talkinbroadway.com	broadwaystars.com (compilations)
americantheaterweb.com	broadway.com
curtainup.com	readio.com
theaterpro.com	leisuresuit.net
theatrereviews.com	totaltheater.com
theatermania.com	

As discussed in the previous chapter, a good press agent will work with the reviewer (arranging tickets on the specific night with the seats at a particular location) to provide assistance and guidance where needed.

Believe it or not, to me, a well-written review can be negative but still send a reader rushing to the box office to purchase tickets. This is because the critic was able to articulate his concerns clearly enough where a reader, who knows his/her own taste, can be compelled to see the work. Conversely, a well written review can speak glowingly of a production but a reader not be inclined to see it because the reviewer's assessment was clear enough so that the reader knew it wouldn't be of interest.

What constitutes a well-written review?

Assuming that the reviewer possesses the necessary qualifications (full knowledge of theater history, working knowledge of play production, as well as necessary communication skills) to present a well-composed review, it should be a critique that analyzes the playwright's intention and then a determination if the creators (director, performers, designers) successfully serviced the play's goals. It should have a cohesive structure and most importantly, the reader should have a sense of whether he'd enjoy the show.

When you read a review, it's important to keep in mind that critics have limitations and are subjected to personal taste.

 # Arts Education

Line up 100 artists and I guarantee you that 90 of them share a major common denominator.

Heck, try lining up 10,000 artists and I still guarantee you that at least 9,000 of them share this major common denominator.

What is it, you ask?

That all but 10% were exposed to the arts sometime during their childhood.

I encourage you to ask your actor friends or dance friends. Or if you know of any theater majors, ask them how they initially got interested. The answers will be familiar—parents, or a teacher, or relative, provided exposure to the arts at a young age.

With the recent funding climate, school boards across the country have been faced with making difficult choices. Unfortunately, all too often, resources in the arts have been compromised with drastically reduced budgets while some districts have removed the arts entirely from the curriculum.

Just think about this for a moment. What happens to our artists of the future if they aren't exposed to the arts during their childhood? They can't become artists by osmosis.

Think about a school district in rural North Carolina not having a basketball program therefore, Michael Jordan may have never been exposed to the sport. Well, then Michael Jordan as a basketball player probably wouldn't have existed either. The same can be true for the next great playwright, composer, and actor, which is why exposure to the arts in school is critical.

Aside from advancing the caliber of the arts, there's another reason to support arts education.

According to a report (Nov. 1998) prepared by Stanford University and Carnegie Foundation For the Advancement of Teaching....

Young people who participate in the arts for at least three hours on three days each week through at least one full year are:

✓ 4 times more likely to be recognized for academic achievement

✓ 3 times more likely to be elected to class office within their schools

✓ 4 times more likely to participate in a math and science fair

✓ 3 times more likely to win an award for school attendance

✓ 4 times more likely to win an award for writing an essay or poem

There's more...

> *"Elementary students who participated in drama to re-create a story they have heard read aloud have greater understanding of the story than those students who only heard the story."*
>
> Critical Links: Learning in the Arts and Student
> Academic and Social Development, 2002, p. 30

And more ...

> *"Many students in a theater acting program reported that the intense review of Shakespeare texts in preparation for performing helped them not only master that difficult material but also improve their reading of other complex material such as math and physics texts."*
>
> Champions of Change, 1999, p. 82 Harvard Project Zero
> from the Shakespeare & Company Research Study

And one more examining the educational value of opera ...

> *"Elementary students involved in creating original opera showed higher rates of classroom participation and quality of participation than their non opera-creating peers. The researchers note the pattern in three opera-creating classrooms, the responsibility for and engagement in creating art is crucial to yielding its broader benefits. The longer students are engaged in the opera-creating process, the more substantial the effects on the quantity and quality of their classroom participation."*
>
> Champions of Change, 1999
> PACE, Harvard Graduate School of Education

Half a Half-Time Show

About a decade ago, facing rising costs, a local urban School Board decided to eliminate its instrumental music program. Eventually the high school marching band was phased out. So at half-time of the district's high school football games, only the visiting team's band performs since the host school does not have a band. Patrons get only half a show.

What's more, the district received a large grant from the state to build a state of the art school complete with two performing venues, a broadcast studio, band and choral rooms, and several instrumental practice rooms.

The administrators need to reevaluate priorities because with no programs in place to expose and teach these children, the brand new facilities won't be of much use.

So the arts can be an effective educational tool when inserted as a part of the regular curriculum. The arts serve to help youngsters in several developmental aspects including:

✓ Increase of discipline through the structure and development of regular rehearsal and practice requirements.

✓ Increase awareness and sensitivity about fellow students, adults and the student's environment.

✓ Allow the student to become more familiar with his emotional composition—both internally and externally.

✓ Increase the student's self-esteem through building confidence.

Arts Training

As noted above, several studies have been conducted citing the value of the arts in the educational curriculum. Now, specifically the training for various disciplines can be wide ranging. But it's important to recognize that all students are different and will develop their craft at their own pace and level.

The most important aspect of training in the performing arts early on is exposure. Students should be given the option to try several different classes, particularly when they are young. They will gravitate towards the classes that they enjoy the most, whether it be dance or tap or trumpet or piano.

Personally, I'm not a big fan of forcing kids to take classes, generally speaking. Once a student reaches the teenage stage, he/she begins to recognize the value and need for further training, particularly if there's an interest in pursuing the arts as a career.

Also at this time, the student is better served to seek out high quality teaching in order to be challenged and pushed to allow for artistic growth.

On a collegiate level, the student has to decide whether to pursue a Fine Arts degree through a conservatory program or a Liberal Arts degree with a general college education.

The one factor for all students to realize is that training never stops—no matter what the discipline. There's always room for the artist to grow either in new directions or a further refinement of existing artistic activities.

Dream of Dr. Martin Luther King Jr.

In his famous 1963 "I Have A Dream" speech, Dr. King indicated that one of his dreams was to have the sons of former slaves and the sons of former slave-owners sit down together at the table of brotherhood.

Well, if you travel to the Hudson Valley in upstate New York you will witness Dr. King's dream alive and well at two prestigious arts schools—the Hudson Valley Conservatory for the Arts and the Mitchell School of Dance. Both schools are providing quality arts training to several generations of youngsters. The value to their respective communities is immeasurable.

Located in Walden, NY, the Hudson Valley Conservatory was established by veteran Broadway actor, Samuel E. Wright. Mr. Wright wanted to give back to his community. Mr. Wright is of African descent. Most of his students are not. This matter is irrelevant as he has trained and influenced hundreds of youngsters throughout the school's history.

Mr. Wright is a strong advocate of combining professional artists with members of the community. "The most effective theater merges professional theater artists with the community. Hard-working, everyday folks who want the chance to perform for people who are tired of spending $100 for a ticket," he states.

Located in Pine Bush, NY, the Mitchell Performing Arts Center (www.mpacdance.net) was first established by Sharon Mitchell in 1985 as a school of dance. Ms. Mitchell is of Trinidadian descent; most of the 100 students in her school are not.

One student of the school is Ms. Mitchell's son, Alexander (who, at age 14, has gone on to be featured in three Broadway productions—*The Lion King*, *A Raisin In The Sun* with Sean 'Puffy' Combs, and *On Golden Pond* with James Earle Jones.

Arts-In-Education

In addition to the training and discipline the arts can provide, there's also a practical use for integrating the arts with traditional educational curriculum where the arts serve as a catalyst for learning. Several organizations throughout the country, like the one listed below, exist to provide this kind of educational component.

Since its founding in 1974, the Creative Arts Team (CAT) has pioneered the use of drama as an educational tool in public schools, becoming internationally known for its innovative practices.

CAT uses theatre as a medium to promote social, emotional, and intellectual growth in communities throughout New York City. Working from early childhood through the adult years, CAT offers interactive dramas that explore curricular themes and social issues such as intercultural understanding, peer pressure, violence, substance abuse, and HIV/AIDS prevention. Audience members become participants in fiction-based group improvisations. Questions emerge from the dramatic conflict, and participants are challenged to find their own answers. Throughout, professionally trained actor-teachers process these experiences so that participants are able to transfer the new skills and insights into their real lives.

Using these techniques allow the students to be active participants in the educational process and this almost universally leads to positive results. Techniques such as role play and re-enactments are conducted under the guidance of professionally trained teacher/actors who work with the classroom teachers to maximize learning potential.

Study Guides

Most theaters create a Study Guide (sometimes called a Resource Guide) for their shows, assuming the subject matter of the play is appropriate for minors. A Study Guide provides resource material for a teacher to use prior to seeing the production. Well-written study guides generally have a structure that includes basic information about:

✓ The play (plot, character, author, etc.)

✓ The original production (reviews, relevant facts, etc.)

✓ The current production (director's concept, design information, cast bios)

✓ Classroom activities (essay questions, games, pre-show/post-show questions)

Most teachers find that Study Guides greatly enhance their theater experiences and provide unique learning opportunities for the students.

As an educator who is a former arts education administrator (Harlem School of the Arts), it's vital that we seriously prepare the next generation of artists and audiences. And it needs to start early in the elementary grades.

The View Inside

OK. I'm going to share with you some industry aspects about the New York theater scene. Some of these are known to the public, and some of them—well, a few of my colleagues might not like me sharing them, but what the heck—it's a free country. So I give to you a few interesting tidbits that form an *inside view* of professional theater in the country's largest and greatest city.

Web Sites

Like most industries, the Internet has transformed how business is conducted. Actors agents no longer send out messengers to deliver their client's pictures/resumes to eager producers and casting directors. They simply email them. You don't have to wait on hold on the telephone endlessly while you wait for service from the Ticketmaster operator—just go to ticketmaster.com and make your purchase. The examples can continue but I think you get the point—the Internet greatly changed our industry.

As a member of the professional theater world, I regularly visit at least four websites on a daily basis. Getting this information keeps me informed about various aspects of theater, in specific, and the entertainment world, in general.

TheaterMania.com

This website is a great resource for producers to market their shows but equally valuable to avid theater fans as they regular send out email discount offers—a service that producers pay for. They also offer ticketing services to small Off Off Broadway companies without the wherewithal to maintain a regular box office.

Editorially speaking they have a cadre of young writers reviewing remote showcase shows as well as Broadway. They also have reputable critics contributing regular columns. I particularly enjoy Peter Felichia's dairy—he's a critic for Jersey's largest newspaper, *The Star-Ledger*, and let me tell you, this man is a walking Playbill as his detailed knowledge about shows he attended 30 years ago is uncanny.

Playbill.com

This site is good for obtaining industry informational updates ... OK, gossip but in a respectable manner. You can see who's recently signed to be in what production—things like that. They also have a good Employment Opportunity section, particularly for Internships. (Hear that college students—great resource to find quality internships).

Variety.com

I check out the Legit section everyday (In fact, it's emailed to me). This information is skewed to the business side of show business. They also review professional shows all over the country—so you can see how that Broadway-bound musical production of *The Color Purple* fared in Atlanta at a simple click of the mouse. One critic that I enjoyed reading, Charles Isherwood, recently left Variety to write for the *NY Times*. Broadway grosses are always informative.

nytimes.com

Recently, an entire section was devoted to Theater by this gold standard publication (yes, in spite of reporter Jayson Blair's alleged plagiarism, the publication is still highly regarded). They have a similar web site for movies. It's a very comprehensive and valuable resource. For example, practically every *NY Times* theater review is available FREE OF CHARGE at the click of a mouse. It's a great value if an actor is researching a role he/she is auditioning for or has just been cast in.

The site boasts Slide Shows offering brilliant photographs of recent productions as well as streaming video reports offering commentary from their critics. (You read these guys for years and it's amusing to suddenly start watching them). Also included is an archive of the drawings of theater cartoonist Al Hirschfeld.

After the recent passing of playwright Arthur Miller, the site posted a special series about Mr. Miller that included current features as well as *NY Times*' articles written about Mr. Miller over the last five decades.

IBDB.com

I remember about ten years ago, when we were researching potential star personalities to cast we could jump on a site called IMDB.com and get all of the movie credits of the star in question. But I'd always want to know if the star in question had any theater chops. I wished for a similar website for theater. Well, a few years ago, the League of Theater Producers launched the IBDB.com—a great database resource that lists virtually all the Broadway casts and credits for the last 80 years. It's a work-in-progress but it's a great resource.

If you are so inclined, go to the site and type my name in—you'll see my one Broadway credit. (My works at Madison Square Garden and Radio City Entertainment aren't eligible, as the League does not deem those venues "Broadway").

Theatre Communications Group

TCG is the national organization for the American theater that offers a wide array of services to strengthen, nurture and promote the professional not-for-profit American theatre. They offer:

✓ Artistic programs supporting theaters and theater artists and offer career development programs for artists.

✓ Management programs providing professional development opportunities for theatre managers.

✓ Advocacy guiding lobbying efforts and providing theatres with timely alerts about legislative developments.

✓ Specialists in dramatic literature, with publications that include *American Theatre* magazine, the *ArtSEARCH* employment bulletin, plays, translations and theatre reference books.

TCG serves over 425 member theatres nationwide. And they're a great resource for artists and administrators in regional theater.

www.tcg.org

The League

Everyone refers to them as "The League"—more formally known as the League of American Theatres and Producers—the national trade association for the commercial theater industry. Members of the League are theatre owners and operators, producers, presenters and general managers of Broadway and touring legitimate theatrical productions.

Formed in 1930 as The League of New York Theatres, the organization's overall goals are to foster increased awareness of and interest in Broadway theatre and support the creation of more profitable theatrical productions.

The League negotiates collective bargaining agreements with all theatrical unions and guilds; coordinates industry-wide marketing initiatives and corporate sponsorships; oversees government relations for the Broadway industry; maintains relevant research archives and databases; and supports charitable efforts for the benefit of the entire theatrical community.

The League also co-produces the Tony Awards® and has established several other programs including Kids' Night On Broadway ®—a nationwide audience development initiative that invites children age 6-18 to the theater for free when accompanied by a paying adult; and the **Generation Broadway** website for kids.

www.livebroadway.com

www.tonyawards.com

Non-Traditional Casting Project

Within the industry, this organization is an absolute treasure. It's been around since 1986 and seeks solutions to the problems of racism and exclusion in film, television and theater. Its mission is to serve as an expert advocate and educational resource for full inclusion in theatre, film, television and related media. Their current focus is to increase the participation of artists of color and artists with disabilities in the industry.

NTCP works to promote inclusive hiring practices and standards, diversity in leadership and balanced portrayals of persons of color and persons with disabilities.

One of the hallmarks of NTCP is the Artist Files On Line—an innovative concept that started a decade ago where members of the non-traditional community comprise a national resource of 3,500 actors' resumes and photographs, as well as the resumes of writers, directors, choreographers, designers and stage managers. It's available on-line free of charge for all professional producers, directors and casting directors. It has been consulted for over 4,600 productions.

www.ntcp.org

On Stage Violence

Acts of violence in the theater present a unique challenge. If the act is too real-looking, it's effectiveness could take the audience out of the moment by wondering if the actor is actually hurting and in pain. Then of course if it looks too staged, then laughter could be detrimental to the scene.

One of the most respected members in the theater community to stage acts of violence is Rick Sordelet, who has staged fights for more than 25 Broadway productions and has more than 1,000 regional credits.

Mr. Sordelet uses a unique combination of stage combat skill and acting techniques to develop fight scenes. This organic approach allows the performer to comfortably stage the violent act.

Next time you see an act of violence on stage at a Broadway show, check the Playbill and chances are it was staged by Rick.

Al Hirschfeld

His brilliant drawings captured the vividness of American theater for almost 75 years in the *New York Times*. Hirschfeld (1903–2003), a self-described "characterist," noted that his contribution was to take the character, created by the playwright and portrayed by the actor, and to reinvent it for the reader. His drawings were a simplistic smooth line style, which simply captured the spirit of the character.

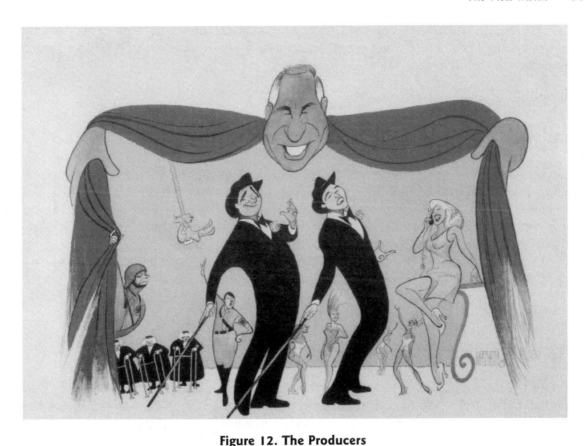

Figure 12. The Producers
See if you can locate the "Ninas."
Image © Al Hirschfield/Margo Feiden Galleries Ltd., New York. www.alhirschfield.com. Used with permission.

Mr. Hirschfeld was also well noted for including the name of his daughter, Nina, in his portraits. It was part of theater lore to find the name craftily located within the drawings. On June 21, 2003, Mr. Hirschfeld's 100-birthday, the Martin Beck Theater was re-named the Hirschfeld in his honor.

www.alhirschfield.com

On Location Education

When you see a young kid acting on stage or in the movies, ever wonder if these kids still have to do their school work? Well, yes and no. These young actors don't go to school because rehearsals and weekday matinees are conducted during the daytime. But, in accordance with educational regulations, they do have to still receive their education through the use of tutors and educational specialists.

When hiring a minor, producers must apply for the appropriate working papers. As a part of that application, the producer must detail an action plan for the young actors' education. Most producers simply pick up the phone and call On Location Education, a full service child tutoring organization. This service handles child work permits, hires tutors and educational

specialists, and conducts the appropriate interaction with the school's principal/teachers. In other words, they perform a unique and valuable service to delivering quality education to child performers of all ages.

www.onlocationeducation.com

Broadway Cares/Equity Fights AIDS

The accomplishments of this organization in such a short period of time are simply miraculous; as it has raised over $100 million since 1988 for critically needed health services. BC/EFA is the nation's leading industry-based, not-for-profit AIDS fundraising and grant making organization. BC/EFA is the on-going, committed response from the American Theatre community to an urgent worldwide health crisis. By drawing upon the talents, resources, and generosity of this community, BC/EFA raises funds for AIDS-related causes across the United States. Recently (2003), this pioneering organization raised close to six million dollars.

www.broadwaycares.org

Discount Tickets to Broadway

I'm going to share a little secret with you that I'm sure will upset some producers. Contrary to popular belief, tickets to most Broadway shows are exceedingly easy to purchase. In other words, there's plenty of extra inventory around. It's important for producers to foster the conception that the show is sold-out and that Broadway is healthy and vibrant, which it is, don't get me wrong. But examining the laws of supply and demand, a fairly decent ticket price can be arranged for several shows. Here's how.

TKTS

The red booth with the exposed awning is a staple of Times Square (actually, the block that it's on is called Duffy's Square). It first opened for business on June 25, 1973, and the booths sells discounted tickets to Broadway, Off-Broadway, Dance and Music events at 25%, 35%, and 50% of full-price (plus a $3.00 per ticket service charge). The only "catch" is the tickets are available on the day of performance. No advance sales. The line moves fairly quickly and there's usually some unemployed actors to entertain you singing and dancing while you wait in line.

www.tdf.org

House Seats

An industry secret—Broadway shows are bound by contract to have available a certain number of house seats for contracted artists. Oftentimes the artists under contract don't utilize these seats but the pools of tickets that are reserved are generally available to industry personnel. All you have to do is make a telephone call to the appropriate representative. These tickets are in prime locations and are never discounted.

Broadwaybox.com

This website is a prize for Broadway theater goers. Avid patrons of Broadway who wanted to support theater started it. The site lists all discounted tickets available for Broadway and Off Broadway shows. Check it out and you'll notice most of the current shows (with the exception of three or four) have discounts available.

> www.broadwaybox.com

Hospital Audiences

HAI is a not-for-profit organization founded in 1969 to provide access to the arts to culturally isolated New Yorkers. HAI service recipients include people with mental and physical disabilities, mentally retarded/ developmentally disabled persons, bed-confined/ wheelchair-users, visually and hearing-impaired individuals, the homeless, the frail elderly, youth at risk, participants in substance abuse programs, persons with HIV/AIDS and individuals in correctional facilities.

I marvel at the artists and staff workers in organizations like HAI who forgo the fortunes of Broadway and willingly work in the trenches to provide services to the less fortunate.

> www.hai.org

Lincoln Center Archives

The NY Public Library for the Performing Arts houses the world's most extensive collection of performing arts archives. The Library's building at Lincoln Center recently reopened after an extensive upgrade of its spaces and technology, providing improved access to its renowned circulating collections and research collections in dance, music, theater, and recorded sound.

In that world famous complex are archival tapings of hundreds of Broadway shows available to the public free of charge.

> www.lincolncenter.org

Hands On

Is a New York City-based service organization dedicated to providing greater accessibility to arts and cultural events for the Deaf and hard of hearing community. Founded in 1982, their mission is to bring the performing and fine arts to Deaf people of all ages. They have interpreters who are trained in signing performances. It's something to behold because they are both narrators (interpreters) and characters all in one. Hands On provides a great service to the deaf community who still want to be a part of the excitement of Broadway.

> www.handson.org

 Theater Appreciation
Worksheets

Play Analysis

Name of play: _____

Author of play: _____

Name of Venue: _____

Type of Theater:

 ____ Proscenium ____ Thrust/Three-quarter

 ____ In-the-round ____ Environmental

Date/Time of performance: _____

Genre of the play:

 ____ Drama ____ Comedy

 ____ Musical ____ Other _____

Was the play a sub-genre (i.e. musical comedy) or new form?

 _____ Yes _____ No

If YES, briefly describe the genre.

Select the basic composition of the story of the play.

_____ Good vs. Evil

_____ Romance—obstacles preventing romance

_____ Underdog triumphing—"David vs. Goliath"

_____ Coming of Age story—developing into manhood or womanhood

_____ Historical drama—tracing true dramatic events

Briefly describe the composition of the Audience (age, socio-economic status, etc.).

How did this audience composition impact your experience of the play?

Was there anything about the physical design and/or structure of the theater that impacted your experience of the play?

_____ Yes _____ No

If YES, briefly describe.

Describe up to three main characters in the play.

 Name *Relationship*

1. _____ _____

2. _____ _____

3. _____ _____

Did you empathize with any of these characters?

 Character #1 _____ Yes _____ No

Discuss either why or why not.

 Character #2 _____ Yes _____ No

Discuss either why or why not.

 Character #3 _____ Yes _____ No

Discuss either why or why not.

What are the objectives of these characters?

 Character #1 _____

 Character #2 _____

 Character #3 _____

What are the conflicts of these characters?

Character #1 (name: _____)

 Internal _____

 External _____

Character #2 (name: _____)

 Internal _____

 External _____

Character #3 (name: _____)

 Internal _____

 External _____

How were the conflicts of the main characters resolved?

 Character #1 _____

 Character #2 _____

 Character #3 _____

In your opinion, were their conflicts resolved satisfactorily?

 Character #1 _____ Yes _____ No

 Explain: _____

 Character #2 _____ Yes _____ No

 Explain: _____

Character #3 _____ Yes _____ No

 Explain: _____

In 25 words or less, describe the playwright's impetus for writing this play.

Please detail a particular acting moment(s) where you feel the performer(s) "took off their mask" to reveal the emotional depth of their character(s).

Scenic Design

 Did the design serve as a "playground" for the actors?

 _____ Yes _____ No

Briefly describe the reasons why.

Costume Design

Discuss the costume(s) of one of the main characters. Briefly describe how the design helped define the character.

Briefly describe how this costume design accentuated the actor's physique.

Lighting Design

Select a particular scene and discuss how the lighting design effectively established the mood and/or locale.

Marketing/Sales

Did you sense that the show's marketing materials captured the essence of the play?

Select how you watched to play...

_____ Actively _____ Passively

Detail the reasons why.
